THE GROUP OF SEVEN
AND TOM THOMSON

AN INTRODUCTION

ANNE NEWLANDS

FIREFLY BOOKS

BOOKMAKERS PRESS

Thanks to Andrew, Martha and Howard

Canadian Cataloguing in Publication Data

Newlands, Anne, 1952–
 The Group of Seven and Tom Thomson : an introduction

Includes index.
ISBN 1-895565-53-7 (bound) ISBN 1-895565-54-5 (pbk.)

1. Group of Seven (Group of artists).*
2. Thomson, Tom, 1877-1917. 3. Painting, Canadian.
4. Painting, Modern — 20th century — Canada.
I. Title.

ND245.5.G7N4 1995 759.11 C95-930034-1

A FIREFLY BOOK

Published by
Firefly Books
250 Sparks Avenue
Willowdale, Ontario
Canada M2H 2S4

Published in the U.S. by
Firefly Books (U.S.) Inc.
P.O. Box 1338
Ellicott Station
Buffalo, New York 14205

Front Cover: Tom Thomson, *Summer Day*, c. 1915; oil on panel, 21.6 x 26.8 cm; McMichael Canadian Art Collection. Gift of Mr. R.A. Laidlaw, 1966.15.18.

Back Cover: Arthur Lismer, *The Guide's Home, Algonquin*, 1914, oil on canvas, 102.6 x 114.4 cm; National Gallery of Canada, Ottawa.

Produced by
Bookmakers Press
12 Pine Street
Kingston, Ontario
K7K 1W1

Design by
Linda J. Menyes
Q Kumquat Designs

Colour separations by
Chroma Graphics (Overseas) Pte. Ltd.
Singapore

Printed and bound in Canada by
Metropole Litho Inc.
St. Bruno de Montarville, Quebec

Printed on acid-free paper

CONTENTS

BRITISH IMMIGRANTS AT UNION STATION TORONTO

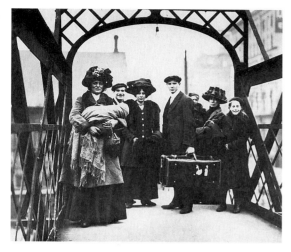

During the early 1900s, Canada was a young country with a fast-growing population. Thousands of hopeful immigrants seeking prosperity were drawn to Canada by the federal government's offer of free land in the West. Although often unprepared for the severe climate and the rugged terrain, these new citizens struggled to clear and cultivate their homesteads, and many flourished along with the country. Canada was in the middle of a wheat boom in 1910, and the boost to the nation's economy led to a demand for tools, machinery, housing and building supplies. In turn, the mining and manufacturing industries began to thrive.

Those not interested in working the land were drawn to large urban communities such as Montreal, Toronto, Winnipeg and Vancouver by the promise of jobs in offices and factories. The cities were hubs of activity, serving as ports of entry for immigration and as centres for trade, commerce and transportation.

By 1910, Toronto—the meeting place of the Group of Seven—was Canada's second largest city after Montreal. As the city sprawled into the countryside, gobbling up surrounding land for housing and industry, the people who travelled from homes to offices, factories and places of entertainment began to demand efficient transportation. In the downtown area, horses still delivered the daily necessities, such as bread, milk and mail, while private cars were used mainly by the rich. When electric streetcars at last provided mass transit, transportation itself became a booming business. Hundreds of jobs were created for streetcar drivers and for the workers required to put down and maintain the constantly expanding network of tracks.

While much of Toronto could still be called "Muddy York," for its many unpaved streets, the centre of the city quickly became an electric web of communication and transportation cables. Electricity replaced coal and gas in homes and offices, furnishing inexpensive power and light, allowing businesses to extend their hours.

Torontonians began to attend a variety of cultural and sports activities in their leisure time. Since the 1890s, movie houses had proved to be steady competition to the live theatres that featured melodramas and comedies imported from London and New York. Music, however, was taking root in native soil, with the formation of the Mendelssohn Choir and what would later be known as the Toronto Symphony Orchestra. In summer, enthusiastic spectators filled the stadiums to watch baseball, while in winter, even greater numbers crowded hockey arenas to enjoy Canada's favourite sport. The city where one of the country's most important groups of painters was about to gather was waking up to the 20th century.

British immigrants arriving at Union Station, Toronto. Photograph courtesy City of Toronto Archives, James Collection.

Toronto Streets: Yonge Street, King to Queen streets, looking north from King Street, 1912. Photograph courtesy Metropolitan Toronto Reference Library.

YONGE STREET
TORONTO, 1912

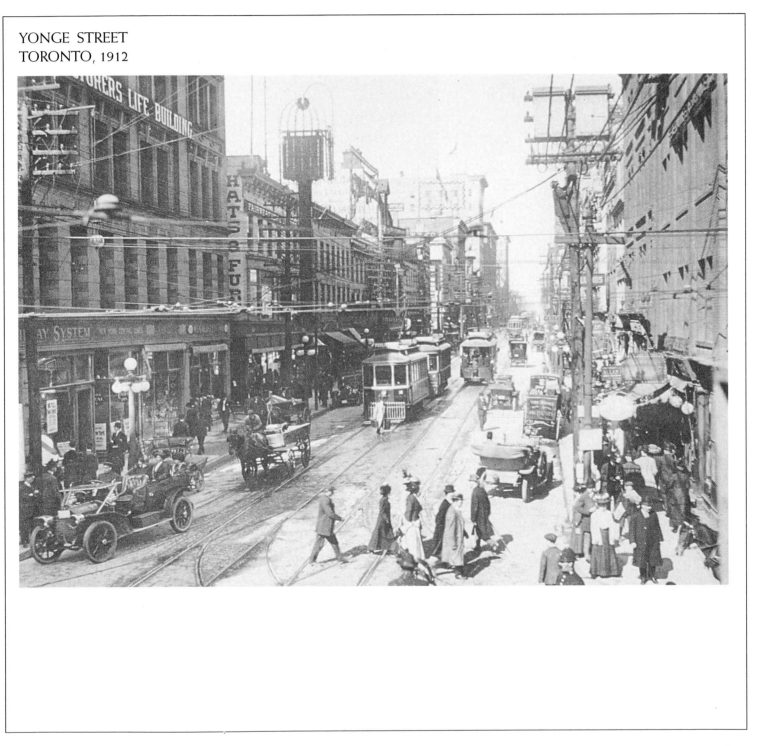

WHO WERE THE GROUP OF SEVEN?

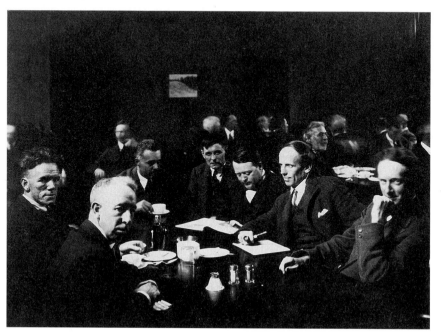

Amidst the hustle and bustle of the booming city of Toronto, a group of artists more interested in the Canadian wilderness than in electric streetcars banded together in a desire to develop a new style of Canadian painting based on the land. Their names were Franklin Carmichael, Lawren Harris, A.Y. Jackson, Frank Johnston, Arthur Lismer, J.E.H. MacDonald and F.H. (Fred) Varley, and in 1920, they formed the Group of Seven. In contrast to the farmers and industrialists who sought to conquer the land and to prosper from it, these artists saw in the untamed terrain a reflection of the country's spirit.

Jackson's *The Red Maple* brings with it a jolt of familiarity. Many of us could guess that this work was painted by one of the Group, but few of us would be able to identify the men in this photograph—the men who brought to life some of the most famous views of the Canadian landscape.

Taken in 1920, the photograph captures a rare occasion: a gathering of most of the Group members about the time they were organizing their first exhibition. Seldom in one place at the same time, these artists energetically pursued their own ambitions and creative dreams, sometimes at opposite corners of the country.

By the time the Group of Seven was established, the artists had known each other for more than a decade—working, laughing, talking and exploring Canada's wilderness, sharing their views and enthusiasm for the North. They called themselves "adventurers in paint," and in a nation where the ambition of many other artists was to imitate the gentle rural scenes of Europe, they set out to be different.

One of the major influences on the Group of Seven was Tom Thomson, a man whose love of the North and rare artistic talent made him a key figure among these friends. Thomson, however, died three years before the Group formed.

"The story of the Group of Seven," said Harris, "is that of seven artists who came together in a creative venture that no one of them could have carried through on his own." Despite their common bond, however, the artists you will read about here were always very much individuals, with distinct personalities and visions.

Fred Varley, A.Y. Jackson, Lawren Harris, Barker Fairley [not a member of the Group], Frank Johnston, Arthur Lismer and J.E.H. MacDonald gather at the Arts and Letters Club, c. 1920. Photograph courtesy McMichael Canadian Art Collection Archives.

A.Y. Jackson, *The Red Maple*, 1914; oil on canvas, 82 x 99.5 cm; National Gallery of Canada, Ottawa.

A.Y. JACKSON
THE RED MAPLE

THE NEED TO BE DIFFERENT

JOHN A. FRASER
SEPTEMBER AFTERNOON, EASTERN TOWNSHIPS

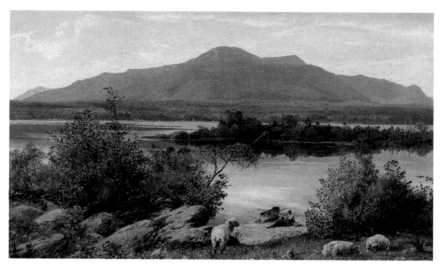

As artists in a young country, the future members of the Group of Seven were struggling to free themselves from the artistic traditions of England, as were the writers and poets of their time. "The European and old-country outlook dominated and dictated our artistic efforts," said Lawren Harris, "…yet the whole environment of the artist in Canada was different from that of the artist in England and Europe." For the artists, this desire to carve out a distinctly Canadian identity was rooted in their dissatisfaction with art that reflected European models.

These two works are examples of the kind of art that was popular with the general public in the late 19th and early 20th centuries. They also serve as examples of how the Group of Seven did *not* want to paint.

In John A. Fraser's *September Afternoon, Eastern Townships*, completed in 1873, the view of Quebec's Mount Orford has the softness of the English countryside. The grazing sheep and the chatting fishermen in the foreground create the impression of a quiet, domesticated landscape. Praised by the critics for its poetic atmosphere and its close attention to the details of the rocks, leaves and twigs, this painting was criticized by younger artists for lacking the true ruggedness of what was essentially a wild, untamed land. Instead, Fraser had engineered a peaceful portrait of the Canadian landscape guaranteed not to frighten away new settlers.

If *September Afternoon, Eastern Townships* was condemned for being too English, paintings such as Horatio Walker's *Oxen Drinking* were denounced for being too Dutch. "Art in Canada," grumbled A.Y. Jackson, "meant a cow or a windmill." Jackson and other artists did not approve of the public's taste for art that glorified the themes of rural work and taming the land. And they felt there was nothing particularly Canadian about scenes such as this one, in which a farmer pauses at the well to water his animals. *Oxen Drinking*, they argued, could have been painted anywhere *but* Canada.

While these artists expressed an undisguised contempt for the European models, the truth was, there was no escaping them. Much of Canada was populated by immigrants who had brought with them a taste for European art, and Europe, as the centre of the art world, continued to be the destination of artists in search of training, including several of the Group of Seven.

John A. Fraser, *September Afternoon, Eastern Townships*, 1873; oil on canvas, 78.5 x 131.3 cm; National Gallery of Canada, Ottawa.

Horatio Walker, *Oxen Drinking*, 1899; oil on canvas, 127.5 x 92.4 cm; National Gallery of Canada, Ottawa.

HORATIO WALKER
OXEN DRINKING

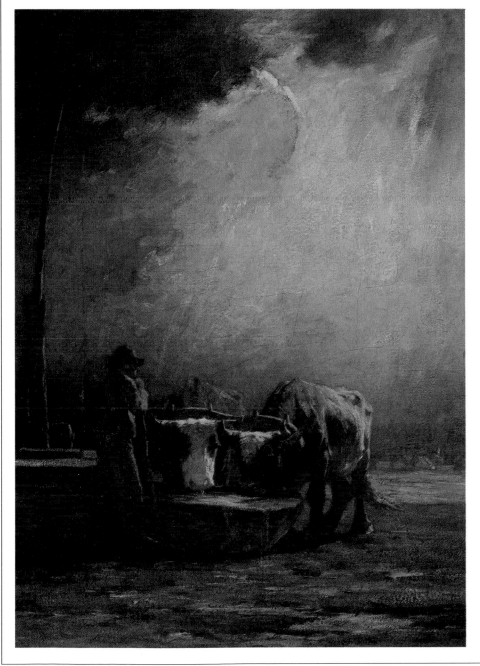

HOW DID THEY MEET?

J.E.H. MacDONALD
BOOKPLATE DESIGN

The artists' first meeting place was a commercial design company named Grip Limited. Located in downtown Toronto, Grip was one of the city's leading design firms at the turn of the century. With the exception of Lawren Harris, who enjoyed an independent income, all the artists who formed the Group supported themselves at one time or another as commercial artists or graphic designers, producing lettering and layout as well as illustrations for magazines and books. At various times between 1908 and 1914, J.E.H. MacDonald, Tom Thomson, Arthur Lismer, Fred Varley, Franklin Carmichael and Frank Johnston worked at Grip in an atmosphere of high-spirited support and encouragement.

The first to arrive at Grip was MacDonald. Emigrating from England at the age of 14 with his parents, MacDonald moved to Hamilton, Ontario, in 1887. Later, he went to Toronto, where he was apprenticed to the Toronto Lithography Company. In 1895, he started to work at Grip, where, after several years, he became a senior designer.

MacDonald was a shy, gentle man who also wrote poetry. Much loved by his fellow artists and considered to be the father of the Group, he was, in the words of A.Y. Jackson, "probably the first to dream of a school of painting in Canada that would realize the wealth of motifs we had all around us."

Tom Thomson was born into a large western Ontario farm family in 1877. Although he expressed an early interest in music and literature, he showed little passion for painting or drawing in his youth. In his early twenties, Thomson tried his hand at a variety of jobs, eventually moving to Seattle, Washington, where he worked as a photoengraver designing commercial brochures, sketching and fishing in his spare time. By 1905, he was back in Toronto, and within a few years, he, too, took a job at Grip. Quiet and reserved like MacDonald, Thomson and his new colleague soon became friends, teaming up with other Grip employees to go on weekend sketching excursions to nearby lakes.

This bookplate design shows the typically Canadian motifs referred to by A.Y. Jackson. A large pine tree with coarse bark and prickly needles dominates the view of windswept waters. J.E.H. MacDonald also used the elegantly curved lettering popular in graphic design at that time. From *Designs for Bookplates* by J.E.H. MacDonald. Toronto: Woodchuck Press, 1966.

Tom Thomson, c. 1904. Photograph courtesy Archives of Ontario. William Colgate Papers. J.E.H. MacDonald, c. 1911. Photograph courtesy McMichael Canadian Art Collection Archives.

TOM THOMSON
c. 1904

J.E.H. MacDONALD
c. 1911

THE ARTS AND LETTERS CLUB

ARTHUR LISMER
THE KNOCKERS' TABLE

Located in an old courtroom behind Toronto's No. 1 Police Station, the Arts and Letters Club was a vibrant meeting place for men interested in the arts. Members gathered there for meals, discussions about cultural activities, exhibitions and musical and theatrical evenings. Because the members' professions and their opinions about art were extremely varied, it was a place where artists of all descriptions felt welcome. Like other cultural clubs and associations in Toronto at that time, the Arts and Letters Club had many enthusiastic debates about "Canadian ideals" and about the importance of Canadian subjects in all of the arts—literature, music and theatre, as well as the visual arts.

The artists from Grip often met at the Club for lunch. Arthur Lismer, a master of caricature, used one such meeting as the subject for this pencil sketch. Called *The Knockers' Table*, the sketch depicts the community's more traditional artists and art critics enjoying a lively exchange of views. This group kidded the Grip artists about their approach to art, sometimes "knocking" them in the press.

The Arts and Letters Club also brought together Lawren Harris and J.E.H. MacDonald. Harris then arranged an introduction between the Grip artists and a rather eccentric Toronto eye doctor named James MacCallum, an avid and accomplished outdoorsman who was eager to support artists who shared his enthusiasm for the Canadian wilderness.

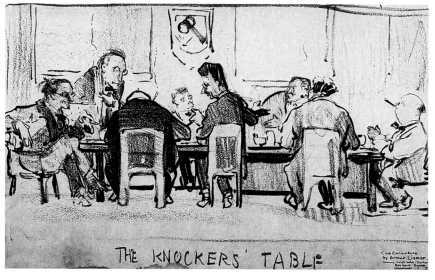

THE KNOCKERS' TABLE

It may be hard to believe that this man, dressed in an old tweed hat and looking out at us with an aloof and disapproving expression, was central to the development of the Group of Seven. Kind and generous, MacCallum regularly invited the artists to his cottage at Go Home Bay on Lake Huron's Georgian Bay, where he often accompanied them on sketching trips. He later offered Tom Thomson and A.Y. Jackson a year's expenses so that they could quit their commercial jobs and devote their full time to painting.

According to Jackson, MacCallum "loved the north country and looked for the feel of it in pictures with the same sense that a lumberjack has for the feel of an axe or that a trapper has for a paddle." He purchased many of the Group's paintings, and he encouraged other collectors and museums, such as the National Gallery of Canada, to show their support as well.

Arthur Lismer, *The Knockers' Table*, 1922; graphite on paper, 46.8 x 77.2 cm; McMichael Canadian Art Collection. Gift of the Arts and Letters Club.

Curtis A. Williamson, *Portrait of Dr. J.M. MacCallum ("A Cynic")*, 1917; oil on canvas, 67.5 x 54.9 cm; National Gallery of Canada, Ottawa. Bequest of Dr. J.M. MacCallum, Toronto, 1944.

CURTIS A. WILLIAMSON
PORTRAIT OF DR. J.M. MacCALLUM ("A CYNIC")

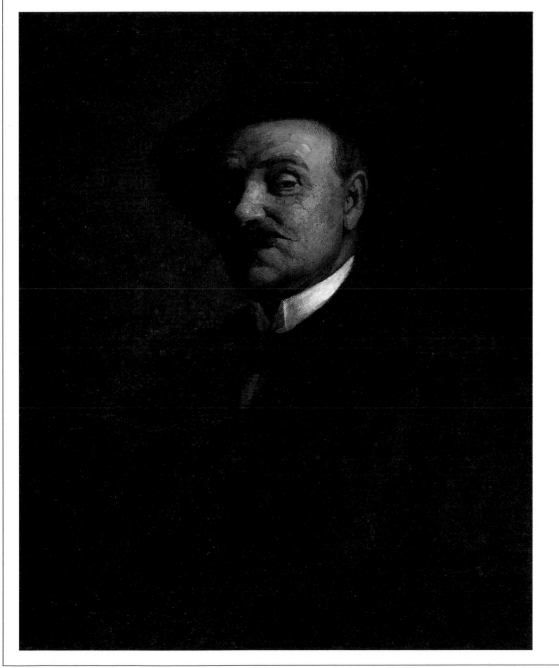

INTRODUCING LAWREN HARRIS

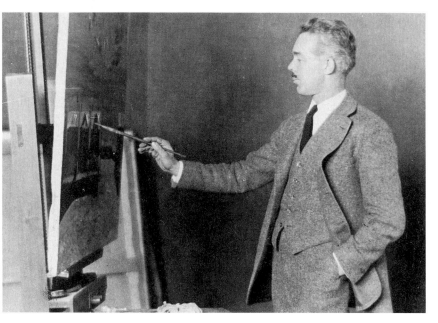

Lawren Harris had a radically different background from that of the other artists who would eventually call themselves the Group of Seven. He was born into a wealthy conservative family that co-owned the farm-machinery company Massey-Harris. Portrayed by A.Y. Jackson as "a handsome man with a head of white hair and a sharp, crisp manner…impeccably dressed in grey flannel suit, white silk shirt and black tie," Harris had the luxury every artist dreams of: he was able to pursue a career in the arts without having to worry about holding down a regular job. "The rest of us were struggling," his fellow artist A.J. Casson remembered, "and he would always do little things to help us, but he did them in a nice way."

Acknowledged by many as the "leader" of the Group of Seven, Harris was a skilled organizer who possessed both vision and determination. "To Lawren Harris," recalled Jackson, "art was almost a mission. He believed that a country which ignored the arts left no record of itself worth preserving."

After attending private school in his youth, Harris was briefly enrolled at university before going to study in Europe, at the age of 19. He returned to Canada in 1908 and was immediately caught up in the cultural scene, becoming a founding member of the Arts and Letters Club.

Harris's first subject after his time in Europe was a series of portraits of houses in what was known as "the Ward," an area around University Avenue and College Street, where much of Toronto's immigrant population lived at the turn of the century. Critics were a little surprised by Harris's painting *The Corner Store*. His family background suggested that a more logical choice might have been the beautiful mansions of Rosedale, rather than the modest homes of the poorer neighbourhood.

But Harris appreciated the simple structure of these buildings, which contrasted with the erratic patterns of shadows cast by the trees in front. He also liked the effects of the bright winter sunlight as it played on the façades of the houses, with their lively red trim and green shutters. For Harris, this was a distinctly Canadian scene, warm and cheerful despite the cold ground of snow and the ice-blue sky.

Lawren Harris, c. 1920. Photograph courtesy National Gallery of Canada, Ottawa (from Beth Harris).

Lawren Harris, *The Corner Store*, 1912; oil on canvas, 88.5 x 66.2 cm; Art Gallery of Ontario, Toronto. Gift from the Estate of Mary G. Nesbitt, Toronto, 1992.

LAWREN HARRIS
THE CORNER STORE

URBAN SCENES AND INDUSTRY

LAWREN HARRIS
THE GAS WORKS

In 1911, J.E.H. MacDonald had an exhibition at the Arts and Letters Club. As his subject, MacDonald had used the countryside near his home in Thornhill, then a small rural village outside Toronto. Lawren Harris found MacDonald's work more moving than any of the paintings he had seen during his stay in Europe. MacDonald had captured what Harris saw as the pioneering spirit of the country. Drawn together by their shared vision, they became close friends. Later, Harris persuaded MacDonald to abandon commercial art altogether, convincing him to quit his job at Grip and become a full-time painter.

Perhaps at the suggestion of Harris, who was himself attracted to urban settings, the two of them sketched together by the railroad tracks and gas-storage tanks along the Toronto waterfront. While the artists have chosen the same subject for the works on these pages, they have treated it in very different ways.

In MacDonald's *Tracks and Traffic*, an industrial vista has been transformed into a billowing vision of light, steam and smoke, capturing the beauty of modern speed and energy. As in the compositions that were to follow this work, MacDonald has seized the big shapes of his subject, moulding them into a flowing panorama.

If you peer through the smoke in MacDonald's painting, you can see the subject of Harris's *The Gas Works*, in which a large gas-storage tank looms ominously, shrouded in grey steam and mist. While this atmospheric softness is unusual for Harris, the geometric solidity of the houses, with their clearly defined rooflines, can also be found in his pictures of the Ward.

This would be the only time that Harris and MacDonald portrayed urban industrial subjects, yet these paintings reveal important themes which each continued to explore later: an interest in the effects of light on snow and a fascination with their immediate environment. To our late-20th-century eyes, the steam and smoke are instantly identified as agents of pollution. But for the artists of that period, these were welcome signs of the economic boom and the beginning of industrial modernization in Canadian cities, when gas replaced wood and coal for cooking and was soon itself to be replaced by electricity.

Lawren Harris, *The Gas Works*, 1911-12; oil on canvas, 58.6 x 56.3 cm; Art Gallery of Ontario, Toronto. Gift from the McLean Foundation, 1959.

J.E.H. MacDonald, *Tracks and Traffic*, 1912; oil on canvas, 71.1 x 101.6 cm; Art Gallery of Ontario, Toronto. Gift of Walter C. Laidlaw, 1937.

J.E.H. MacDONALD
TRACKS AND TRAFFIC

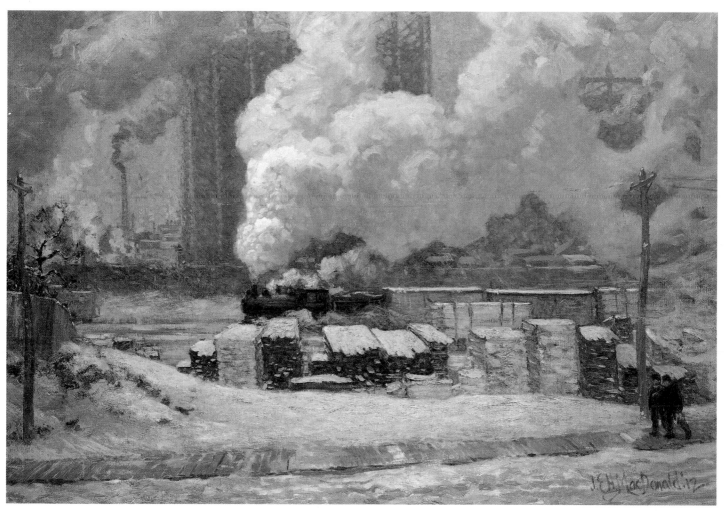

THE SCANDINAVIAN INFLUENCE

GUSTAV FJAESTAD
WINTER MOONLIGHT

In 1913, Lawren Harris and J.E.H. MacDonald decided to travel to Buffalo, New York, to view an exhibition of contemporary Scandinavian landscape painting. Afterward, Harris described the experience as one of the most rewarding that either of them had ever had.

What most impressed them about the Scandinavian work was its devotion to northern subjects—wilderness landscapes, winter and the snow itself—and its vigorous and decorative depiction of these themes. Here, the forms of nature were powerful and sculptural, thickly painted, evoking the very ruggedness of the country itself. The Canadians saw a reflection of their own yearning to celebrate what was dear to them about their land. "This is what we want to do with Canada," declared MacDonald.

Despite what the artists said later about the aims of the Group of Seven to forge a distinctly Canadian style, the strong and lasting effects of the show on these artists meant that they would never be entirely free of European influences.

Gustav Fjaestad's *Winter Moonlight* was one of Harris and MacDonald's favourites. In a lecture on Scandinavian art delivered many years later, MacDonald recalled his admiration: "The decorative foliage of his snow-hung boughs [had] a delicate charm we had never seen in art before. It all had a great Canadian inspiration for us… the finely harmonized pinks and purples and blues and cream-yellows of Fjaestad's colourful

snow." Fjaestad was, said MacDonald, "a remarkable gatherer and presenter of nature's design," who had created "true souvenirs of that mystic north round which we all revolve."

In MacDonald's *Snow-Bound*, we can see a similar use of soft pastel colour to portray a snow-laden spruce tree, which presses toward the ground with its weight. Focusing on the curving lines of the branches, which contrast with the sculptured mass of the snow, MacDonald offers a view of winter that is still and peaceful. Beyond simply describing the appearance of nature, MacDonald is trying to express the way that nature makes him feel.

Gustav Fjaestad,
Winter Moonlight, 1895;
Nationalmuseum,
Stockholm.

J.E.H. MacDonald,
Snow-Bound, 1915;
oil on canvas,
51.1 x 76.5 cm;
National Gallery of
Canada, Ottawa.

J.E.H. MacDONALD
SNOW-BOUND

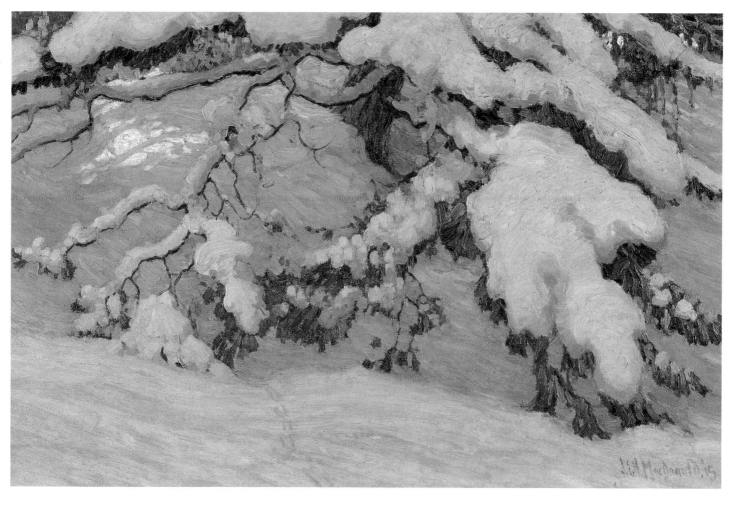

A.Y. JACKSON MOVES TO TORONTO

A.Y. JACKSON
IN FRONT OF *FIRST SNOW, ALGOMA*

W hen Arthur Lismer, J.E.H. MacDonald, Tom Thomson and Lawren Harris saw A.Y. Jackson's *The Edge of the Maple Wood* in an Ontario Society of Artists exhibition in 1913, Lismer reported that the painting stood out from the usual "array of collie dogs, peonies and official portraits like a glowing flame packed with potential energy and loveliness." Thomson, equally excited, declared that it opened his eyes to the possibility of the Canadian landscape.

Like the Grip artists, Jackson had begun his career as a commercial artist. Before studying art at night in Montreal and later at the Académie Julian in Paris, he had earned his living designing barrel labels and cigar bands. By the time the Toronto artists saw *The Edge of the Maple Wood*, Jackson was making plans to move to the United States, so discouraged was he by the reception his paintings had received in Montreal. After the Toronto exhibition, MacDonald wrote to him, explaining that Harris wanted to buy the painting—if Jackson still had it. In his autobiography, *A Painter's Country*, Jackson wryly recalls that at the time, he still owned every picture he had ever painted.

Harris bought *The Edge of the Maple Wood* and invited Jackson to come to Toronto to meet the other artists who wanted to break free of the European traditions and, Jackson recalled, "to paint our own country as it was." Thus began, Jackson wrote, his "association with the artists responsible for changing the course of Canadian art for many years to come."

In *The Edge of the Maple Wood*, the large shadow of a maple—cast by a tree outside the picture—fills the foreground of the painting, leading our eyes back to the split-rail fence and the bright spring sky. There is an atmosphere of openness and airiness as nature awakens to the first warmth of the season.

While Jackson admits that after "the soft atmosphere of France, the clear, crisp air and sharp shadows of my native country in the spring were exciting," the painting nevertheless acknowledges the effect of his recent studies in France and the influence of a style of painting called impressionism, in which artists used short strokes of bright colour to give the feeling of light and movement in nature.

A.Y. Jackson in front of *First Snow, Algoma* (1919-20; McMichael Canadian Art Collection). Photograph courtesy Dr. Naomi Jackson Groves.

A.Y. Jackson, *The Edge of the Maple Wood*, 1910; oil on canvas, 54.6 x 65.4 cm; National Gallery of Canada, Ottawa.

A.Y. JACKSON
THE EDGE OF THE MAPLE WOOD

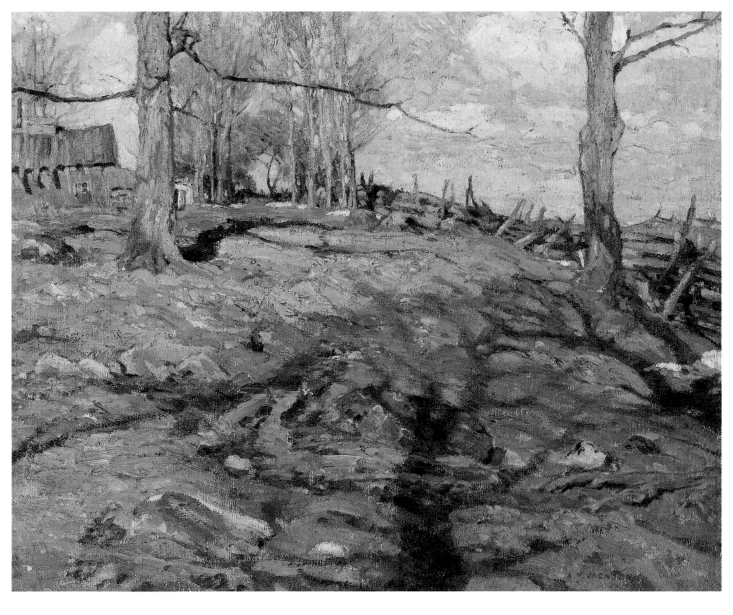

PLACES TO PAINT IN THE CITY

THE STUDIO BUILDING
SEVERN STREET, TORONTO

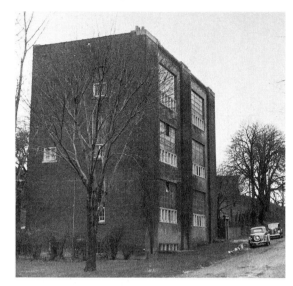

While the meetings at the Arts and Letters Club were a great source of social support for the artists, what they really needed was an inexpensive studio space where they could exchange ideas and have enough room to work on large canvases. "Most of the artists could paint only on weekends and holidays and in small and poorly lighted quarters," reported A.Y. Jackson, concluding that a common space was necessary.

Lawren Harris proposed building a studio with enough room for all of them. Since Harris alone had the financial means to take on a project

of this sort, he donated three-quarters of the money. Dr. James MacCallum contributed the rest. Land was purchased, and plans were drawn up by an architect who was also a member of the Club. The Studio Building, as it was called, was constructed on Severn Street, near the corner of Bloor and Yonge streets, where it still stands. The first building of its kind in Canada, its main occupants, according to Harris, were "artists doing distinctively Canadian work."

When the Studio Building was completed in January 1914, Jackson and Tom Thomson were the first to move in, followed by Harris and J.E.H. MacDonald. Arthur Lismer liked to work at home, and Fred Varley preferred to be on his own. Franklin Carmichael arrived in the fall of 1914. "No artist in Canada ever worked under happier conditions," wrote Jackson, who continued to paint in the Studio Building until 1954.

In the fall of 1915, when Thomson returned to Toronto from Algonquin Park, Jackson, his studio mate, had gone off to war. Thomson could not afford the rent on his own. In order to stay close to his friends, he decided to move into an old cabinetmaker's workshop behind the building. As Harris reported: "We fixed it up, put down a new floor, made the roof watertight, built in a studio window, put in a stove and electric light. Tom made himself a bunk, shelves, a table and an easel and lived in that place as he would a cabin in the North. It became Tom's shack and was his home until he died in 1917."

The Studio Building, Severn Street, Toronto, Ontario. Photograph courtesy National Gallery of Canada, Ottawa.

A.Y. Jackson, *Tom Thomson's Shack*, c. 1942; graphite on paper, 22.1 x 29.7 cm; McMichael Canadian Art Collection. Gift of the Founders, Robert and Signe McMichael.

A.Y. JACKSON
TOM THOMSON'S SHACK

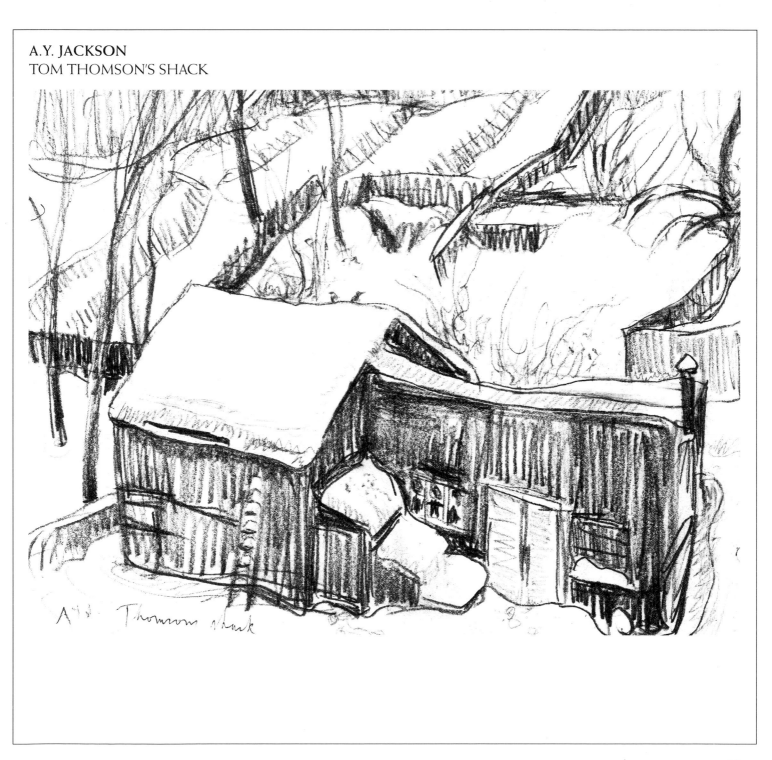

FRIENDSHIPS AND EXCHANGES

TOM THOMSON
TEA LAKE DAM

A vast forestry reserve north of Toronto, Algonquin Park stretches between Georgian Bay on the west and the Ottawa River to the east. Since the turn of the century, the park has served as a peaceful retreat for city dwellers trying to escape the increasing noise and activity of urban life. Parts of it are pristine wilderness, making it an ideal place for artists interested in sketching the rugged beauty of the Canadian Shield.

In the summer and fall of 1912, Tom Thomson made his first extended sketching trip to Algonquin Park. Returning to Toronto with a bundle of sketches, he was filled with enthusiasm about his experience. His excitement was infectious, and gradually, the artists who shared space in the Studio Building took short trips with Thomson, discovering the North for themselves.

At Thomson's urging, A.Y. Jackson was the first to make the journey. "He would tell me about canoe trips, wildlife, fishing, things about which I knew nothing," Jackson recalled in *A Painter's Country.* "In turn, I would talk to him of Europe, the art schools, famous paintings I had seen and the impressionist school which I admired....He talked of his beloved Algonquin Park so much that I decided to see it for myself. I arrived there late one night in February...it was 45 degrees below zero."

In a letter to Dr. James MacCallum in 1914, Arthur Lismer commented on the productive nature of the relationship between Thomson and

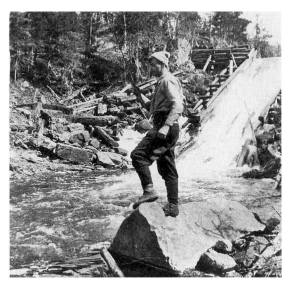

Jackson, noting that each was "having a decided influence on the other: Thomson...seems to be selecting his material carefully and using a finer sense of colour...Jackson has some brilliant work. ...The material here is more intimate and suits his aggressive soul better, I think."

In *Frozen Lake, Early Spring, Algonquin Park,* we see Jackson's initial response to the northland. Compared with the artist's point of view in *The Edge of the Maple Wood*—and perhaps as a result of Thomson's influence—Jackson moved in closer to nature, giving us the feeling that we, too, are snowshoeing over the sun-flecked snow, peering through the leafless trees at the frozen ice-green lake. This view of the water through trees was to become a favourite compositional device with the members of the Group of Seven, who, in their travels through the bush, were frequently greeted by such a screen of trees.

Tom Thomson at Tea Lake Dam. Photograph courtesy National Gallery of Canada, Ottawa.

***A.Y. Jackson, Frozen Lake, Early Spring, Algonquin Park,* 1914; oil on canvas, 81.4 x 99.4 cm; National Gallery of Canada, Ottawa. Bequest of Dr. J.M. MacCallum, Toronto, 1944.**

A.Y. JACKSON
FROZEN LAKE, EARLY SPRING, ALGONQUIN PARK

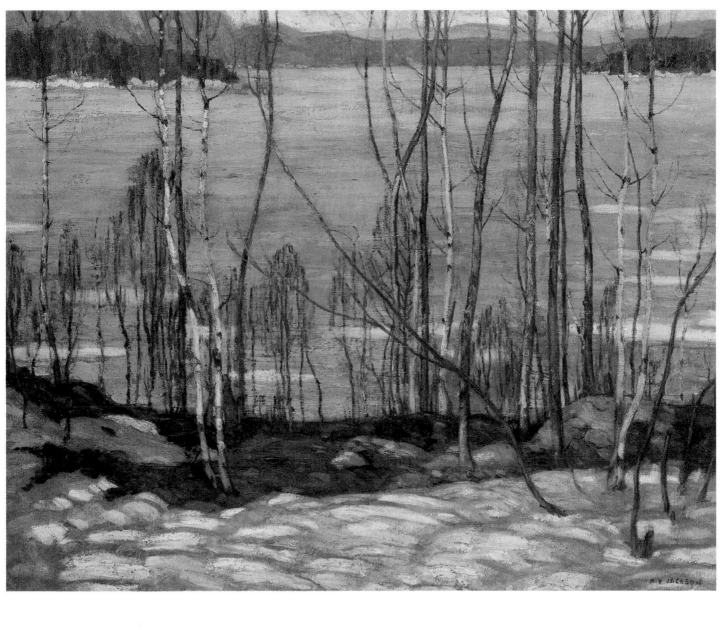

FROM PANEL TO CANVAS

TOM THOMSON
STUDY FOR "SPRING ICE"

As well as the usual gear that travelling deep into the bush requires—food, shelter, cooking utensils and clothing—the artists also had to transport their painting and sketching materials, adding even more weight to their heavy packs. Forced to keep their art supplies to a minimum, they worked on small birch panels, each about the size of a sheet of writing paper.

When working directly from nature, the artists had to paint or draw rapidly, especially if the weather was cool or wet. We can imagine Tom Thomson creating this sketch for *Spring Ice*, squatting close to the thawing earth and balancing his sketch box on his knee to get a ground-level view of the river. We can almost feel the crisp spring air chilling his fingers, the same brisk temperature preventing the ice on the river from melting. Summer is far away, the earth is muddy brown, and the buds on the trees have not yet opened.

This sketch inspired Thomson to produce a larger painting, which he completed the following winter in his shack in the city. While the composition—the arrangement of land, trees, lake and rocks—is similar to that of the sketch, Thomson's use of colour on the canvas is strikingly different. The painting also has a wider horizontal shape than the sketch, which allowed the artist to pay greater attention to the expanse of cold blue lake. Instead of the dull greens and browns of the sketch, Thomson has used bright pastel colours that he hoped would express the *idea* of spring, colours suggestive of new growth and nature's rebirth.

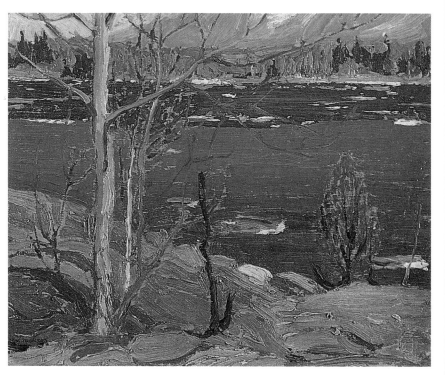

This is only one of many examples of a sketch and the painting that came after, but it is important to note that the artists did not always view these sketches simply as studies for larger works. To create them, they worked quickly and spontaneously, by the light of the sun or the moon, striving to capture the many moods of nature—a nature sometimes quiet and serene, as we see in *Spring Ice*, and sometimes wild and stormy, as we will see in other works.

Tom Thomson, *Study for "Spring Ice,"* 1915; oil on cardboard, 21.6 x 26.7 cm; National Gallery of Canada, Ottawa. Bequest of Dr. J.M. MacCallum, Toronto, 1944.

Tom Thomson, *Spring Ice,* 1916; oil on canvas, 72 x 102.3 cm; National Gallery of Canada, Ottawa.

TOM THOMSON
SPRING ICE

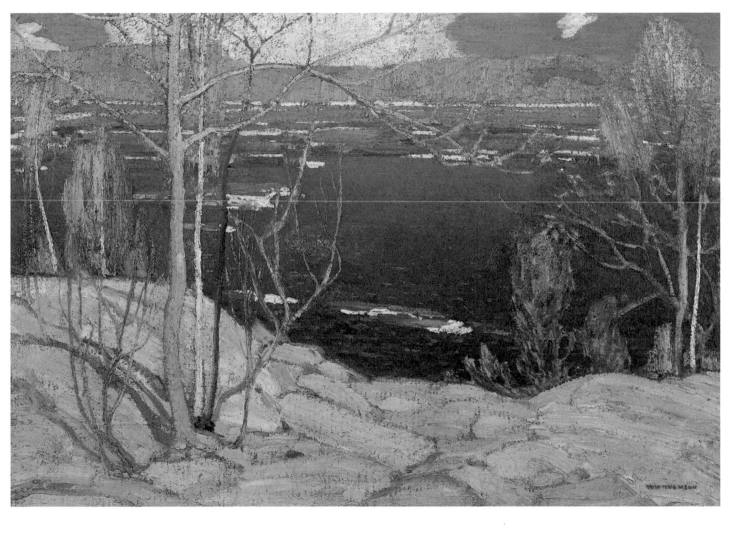

ARTHUR LISMER
STUDIO PORTRAIT

Born and raised in the smoky industrial city of Sheffield, England, in 1885, Arthur Lismer loved to draw, even from an early age. Although his family were not artistic, they appreciated his talents and were proud and supportive when, at the age of 13, he won a scholarship to the Sheffield School of Art. While the local school provided Lismer with a good foundation in design for commercial and industrial products, he was forced to look elsewhere for training in fine art.

Following the example of other Sheffield artists, Lismer travelled to Antwerp, Belgium, to study at the Académie royale des beaux-arts. Returning from his European sojourn to a bleak job market at home, Lismer took the advice of friends and immigrated to Toronto in 1911 to find work as a commercial artist. There, he got a job at Grip, where he met J.E.H. MacDonald, Tom Thomson and Frank Johnston.

Like his co-workers, Lismer joined the Arts and Letters Club. After meeting Lawren Harris, he also became associated with the artists in the Studio Building, throwing himself with great enthusiasm into their adventurous treks into the northern Ontario bush.

In a letter to his wife, Lismer described a three-week sketching trip with Thomson in May 1914: "The first night spent in the North and the thrilling days after were turning points in my life…the bush, the trails, lakes, waterfalls …moving camp from one wonderful lake to another—portage and tent pitching, fishing and sketching—and above all, the companionship of a great individual, a wonder with canoe, axe and fish line."

The Guide's Home, Algonquin was inspired by Lismer's second visit to Algonquin Park, in the fall of 1914. While the painting captures the warm sunniness of the brilliant autumn foliage, Lismer was still seeing Canada through the eyes of the French impressionists—not surprisingly, given that these famous artists celebrated painting *en plein air*, or outside. Using small dabs of pure colour, Lismer borrowed their method to capture the light and movement of nature. This experiment with impressionism was a step in the search for a style that would better reflect the actual ruggedness of the wilderness.

Arthur Lismer. Photograph courtesy E.P. Taylor Reference Library and Archives, Art Gallery of Ontario, Toronto.

Arthur Lismer, *The Guide's Home, Algonquin*, 1914; oil on canvas, 102.6 x 114.4 cm; National Gallery of Canada, Ottawa.

ARTHUR LISMER
THE GUIDE'S HOME, ALGONQUIN

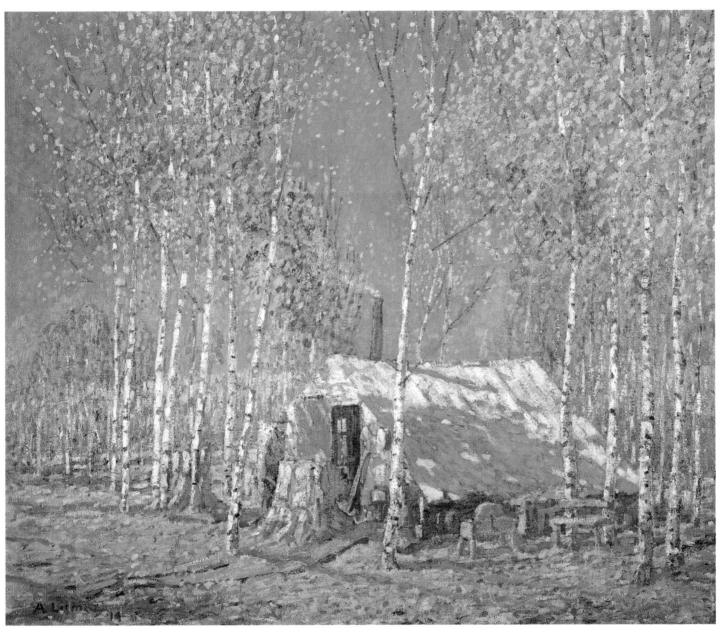

PORTRAIT OF AN ARTIST

It was thanks to Arthur Lismer that Fred Varley, also a native of Sheffield, England, came to live in Canada. Born in 1881, Varley had found ready support for his early interest in the arts from his father, who worked as a commercial illustrator. Practically minded about their son's education, his parents enrolled the 11-year-old Varley at the same art school which Lismer would later attend so that he might be trained in the rudiments of commercial art. Varley then headed to Antwerp, Belgium, where he received medals for drawing and painting during the two years he studied at the Académie royale des beaux-arts.

Varley's luck at finding work in England after art school, however, was not much better than Lismer's. In 1912, when Lismer returned briefly from Canada to marry, he was enthusiastic about the job possibilities in Toronto, and Varley, who already had a young family to support, decided to immigrate there as well. Soon after his arrival, he was offered a job at Grip. Shortly after that, he moved to the commercial art firm Rous and Mann, where he met Tom Thomson and the other artists who convened regularly at the Arts and Letters Club.

Varley enjoyed the camaraderie of this group of artists and accompanied them on sketching trips, but he did very little oil painting before the First World War. Lismer, with characteristic wit, described his countryman's relationship to the Group of Seven by saying that Varley could not "be blamed for anything they did" and that Varley was not a strong believer in "painting the Canadian scene in a Canadian fashion. But the Group got him painting, and his efforts did appear in their exhibitions."

Unlike the other members of the Group, Varley preferred painting people to painting trees. This self-portrait followed his return to Canada after the war and acquaints us with Varley's appearance. Lismer described him rather graphically as "a man with a ruddy mop of hair…which burned like a smouldering torch on top of a head that seemed to have been hacked out with a blunt hatchet. That colour was the symbol of a fire in his soul."

The painting also introduces us to Varley's manner of using colour to express emotions. Here, the sombre dark browns and greens create a serious or sad mood, perhaps a reflection of Varley's feelings following the horrors he had witnessed on the battlefields of Europe. Despite the deep shadows, his eyes stare out at us with a lively intensity that captures his restless and rebellious character.

F.H. Varley, *Self-Portrait*, 1919; oil on canvas, 60.5 x 51 cm; National Gallery of Canada, Ottawa.

F.H. VARLEY
SELF-PORTRAIT

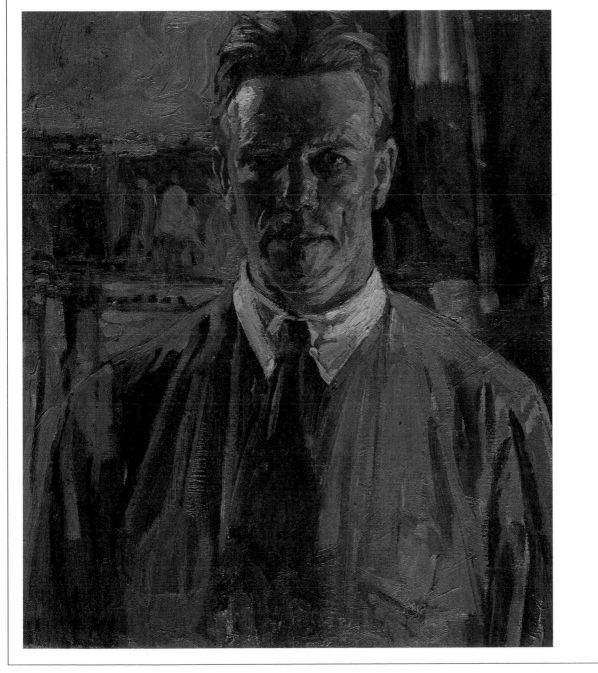

THE ARTISTS IN ALGONQUIN PARK
OCTOBER 1914

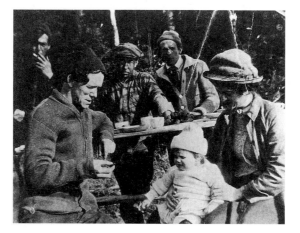

This photograph, taken in October 1914, marks the only time that Tom Thomson, Fred Varley, A.Y. Jackson and Arthur Lismer sketched together in Algonquin Park. It was also the last time that Jackson and Varley would sketch with Thomson. According to Jackson: "That autumn of 1914 was wonderful, with sunny days and frosty nights....In the evening by the campfire, we discussed plans for the next day while we cooked good, husky meals."

Exploring the forests and lakes together helped the group of friends to unify and consolidate their ideas. Varley said that they were "all working to one big end...emptying ourselves of everything except that nature is here in all its greatness." This enthusiasm was, unhappily, short-lived. In the summer of 1914, the First World War had broken out in Europe, and the artists would soon go their separate ways. Jackson, Varley and Lawren Harris enlisted, and Lismer eventually moved to Halifax to take a teaching job. That left only Thomson and J.E.H. MacDonald in Toronto.

During the war years, Thomson continued to spend the majority of his time in the bush working as a guide. His painting *In the Northland* was developed from a sketch made during the trip to Algonquin Park in the fall of 1914. In a letter to Dr. James MacCallum, Thomson modestly reported: "The maples are about all stripped of leaves now, but the birches are very rich in colour...the best I can do does not do the place much justice in the way of beauty."

Recalling the composition of Jackson's *Frozen Lake, Early Spring, Algonquin Park*, with its view of a lake through a screen of trees, Thomson captures the last sunny warmth of autumn as the red and golden leaves contrast with the cool crystal blue of the lake and the brilliant white of the birch trees. The boldness of Thomson's use of colour is balanced by the boldness of the composition itself: the clumps of fallen leaves and heavy rocks are reduced to large, simple shapes and contrast with the narrow strips of tree trunks. To vary the repeated pattern of vertical trees, Thomson shows a fallen birch cutting through the middle ground, leading our eyes to the lake and the shore in the distance.

Thomson worked from intuition and a feeling about nature, and it was the strength and simplicity that he brought to his paintings which impressed the other artists. "Not knowing all of the conventions of beauty," said Jackson about his friend, "he found it all beautiful."

Algonquin Park, October 1914. From the left, Tom Thomson, Fred Varley, A.Y. Jackson, Arthur Lismer, Marjorie Lismer and Mrs. Esther Lismer. Photograph courtesy E.P. Taylor Reference Library and Archives, Art Gallery of Ontario, Toronto.

Tom Thomson, *In the Northland*, 1915; oil on canvas, 101.7 x 114.5 cm; Collection of the Montreal Museum of Fine Arts. Gift of Friends of the Montreal Museum of Fine Arts.

TOM THOMSON
IN THE NORTHLAND

MacDONALD BATTLES THE CRITICS

Before the Group of Seven was officially formed in 1920, several of its members had already held small exhibitions. Some critics praised their work for the way it reflected "a Canadian spirit." Others, however, were shocked by the artists' bold use of colour, their broad, sweeping brush strokes and their lack of attention to specific details.

They are strong paintings, and they provoked strong reactions. As early as 1913, one Toronto writer had labelled them the "Hot Mush School." The news, though, was not all bad. "Strength and Beauty in the New Pictures," read one headline in *The Toronto Star*. "Ontario Artists Do Vigorous Work," said another in the *Mail and Empire*. And the National Gallery of Canada, an early supporter of the artists, continued to purchase and exhibit their works. But creating controversy was better than being ignored; the artists were happy to have the attention.

In 1916, J.E.H. MacDonald's *The Tangled Garden* set off another alarm. Hector Charlesworth, a critic for *Saturday Night* magazine, accused MacDonald of throwing "his paint pots in the face of the public." *The Tangled Garden*, he insisted, was far too large for its extremely ordinary subject matter. Unruly gardens, he argued, should not be painted in dimensions of four by five feet. Large canvases should be reserved for important subjects—scenes from history and famous people. Nor was Charlesworth alone in his disapproval of the "crudity of colours" that seemed to overwhelm the "delicate tracery of vegetation."

MacDonald rose to the assault with wit, enjoying the battle of words. In his article "Bouquet From a Tangled Garden," he explained that *The Tangled Garden* and paintings like it were attempts to capture "the spirit of our native land." They should not, he said, be criticized by men who were more familiar with the footlights of the stage than with the sunlight of the countryside.

What is our response to *The Tangled Garden?* Some might notice the barn and the ancient gnarled trees in the background and be reminded of their own happy experiences in country gardens, where there are mysterious places to hide and explore. Others might instead focus on the large, drooping sunflower heads and the overgrown bed of colourful blossoms that seems to creep out of the picture frame toward us. As we are drawn into the glorious, chaotic tangle of lines and colours in a garden gone wild with growth, the powerful scent of late summer is in the air.

Whether or not we appreciate *The Tangled Garden*, we might still be a little surprised at the uproar caused by a painting of a simple country garden. Perhaps it is an important reminder that new things are often perceived as a threat, whether they appear on the street or on the walls of the local art gallery.

J.E.H. MacDonald, *The Tangled Garden*, 1916; oil on beaverboard, 121.4 x 152.4 cm; National Gallery of Canada, Ottawa. Gift of W.M. Southam, F.N. Southam and H.S. Southam, 1937, in memory of their brother, Richard Southam.

J.E.H. MacDONALD
THE TANGLED GARDEN

YEARS OF TRAGEDY

F.H. VARLEY
THE SUNKEN ROAD

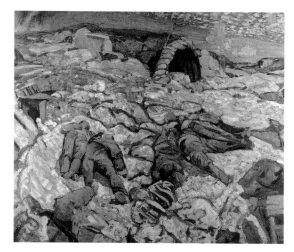

When the First World War broke out in Europe in 1914, life everywhere was disrupted. Thousands of Canadians supported the war effort by joining the armed services or by doing volunteer work for organizations such as the Red Cross. The federal government poured money into producing weapons and other military supplies to be sent overseas, and the increasing strain on the economy caused the rate of unemployment to rise.

Because of the reduced demand for commercial artwork, artists had to look to other sources for income. Franklin Carmichael returned to his job as a carriage painter, Tom Thomson worked as a wilderness guide in Algonquin Park, and Arthur Lismer travelled to Halifax to become the principal of an art school. J.E.H. MacDonald's health was too fragile to allow him to go to war, but A.Y. Jackson, Fred Varley and Lawren Harris all enlisted.

The brutal reality of war had a profound effect on Varley, who was commissioned by the military as an artist. In his painting *The Sunken Road*, the broken bodies of a slaughtered German gun crew lie sprawled in the mud amid fragments of exploded machinery and a ravaged landscape. While the blue sky and rainbow in the background offer the viewer a modest ray of hope, they cannot compete with the senseless ruin in the foreground, which expresses Varley's overwhelming horror with war.

At home, news of the tragic drowning of Tom Thomson in Algonquin Park devastated the group of friends. Thomson's body was discovered more than a week after he set out on Canoe Lake on July 8, 1917, but the details of the death of this expert canoeist and experienced woodsman remain shrouded in mystery.

Jackson spoke for all who had known Thomson when he wrote: "Without Tom, the north country seems a desolation of bush and rock. He was the guide, the interpreter, and we the guests, partaking of his hospitality so generously given."

The Jack Pine is one of the last major canvases that Thomson completed before his death. Outlined in red, the lone tree stands majestic and still, backlit by the setting sun. Bold horizontal strokes of green, purple and pink describe the evening sky and are echoed in the calm waters, adding to the feeling of peacefulness at day's end. In the distance, the blue silhouettes of the hills create a curving horizon line; in the foreground, the solitary pine unites all of these elements.

We can only imagine what Thomson intended to say in this painting. Was he expressing a sense of isolation from his friends or simply the tranquillity he experienced alone in the North?

F.H. Varley, *The Sunken Road,* 1919; oil on linen, 132.4 x 162.8 cm, CN #8911; Copyright Canadian War Museum. Photography for CWM by William Kent.

Tom Thomson, *The Jack Pine,* 1916-17; oil on canvas, 127.9 x 139.8 cm; National Gallery of Canada, Ottawa.

TOM THOMSON
THE JACK PINE

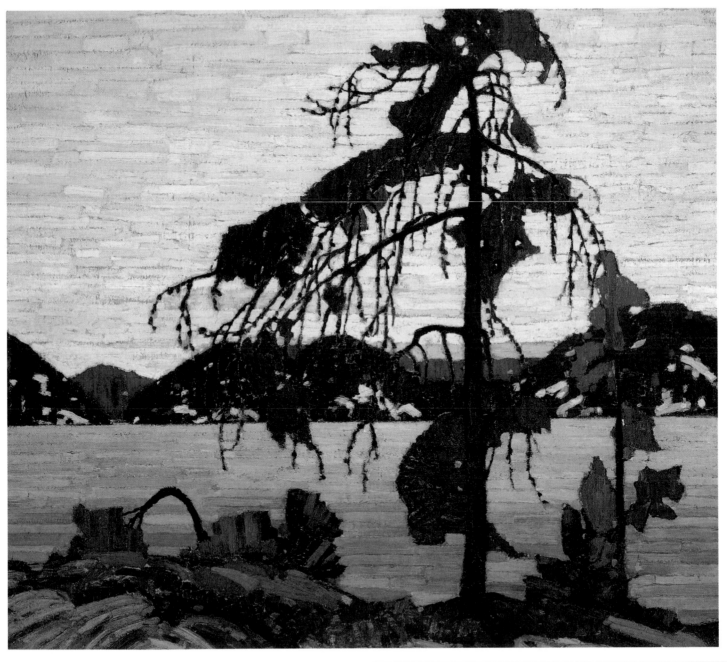

THE ARTISTS REUNITE

FRANK JOHNSTON
c. 1920

Lawren Harris received an early discharge from the Canadian Army for medical reasons, and in the spring of 1918, he and Dr. James MacCallum travelled to northern Ontario's Algoma region, east of Lake Superior, where they found "a rugged, wild land packed with an amazing variety of subjects."

One by one at war's end, the artists resumed their former lives. For the next few years, several of them followed Harris's lead and made an annual trek to Algoma, where they stayed in an old boxcar donated by the Algoma Central Railway. Harris recalled that it boasted "a few windows, four bunks, a stove, water tank, sink, cupboard, two benches and a table." The car was hauled up the line by a freight train to their chosen destination and then shunted onto a sideline. A handcar was loaded into the boxcar and used to take them up and down the tracks. For travel on lakes and rivers, they took along a canoe.

In the fall of 1918, Harris and MacCallum invited J.E.H. MacDonald and Frank Johnston to join them. While Johnston's official association with the Group of Seven was to be brief, his friendship with the artists dated back to 1908, when he, too, worked for Grip. Through his contacts there and as a member of the Arts and Letters Club, Johnston met Harris and the other artists. Like them, he enjoyed weekend sketching trips to various parts of Ontario.

Approaching Storm, Algoma gives us an idea of Johnston's response to the richness and colours

Frank Johnston. Photograph courtesy E.P. Taylor Reference Library and Archives, Art Gallery of Ontario, Toronto.

———

Frank Johnston, *Approaching Storm, Algoma,* 1919; tempera on board, 30.7 x 30.7 cm; McMichael Canadian Art Collection. Gift of the Paul Rodrik Estate.

of the Algoma landscape in autumn. Using quick-drying tempera, which tends to be opaque, rather than the slower-drying oil paint used by the other artists, Johnston was able to layer the colour without blending it. Here, the bright yellows and golds of some of the foliage stand out against the deep green fir trees and the dark grey sky. Probably sketching as the clouds rolled in, Johnston seems to have worked quickly, pressing his paintbrush down against the surface of the board to create the uneven jagged shapes of the leaves. In so doing, he has captured the excitement we feel just before the storm's arrival forces us to run for shelter.

FRANK JOHNSTON
APPROACHING STORM, ALGOMA

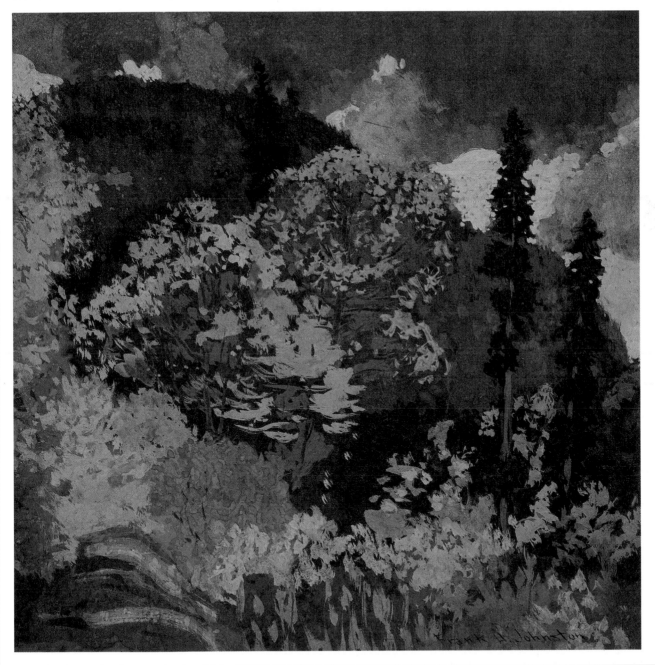

MEET FRANKLIN CARMICHAEL

FRANKLIN CARMICHAEL
STUDIO PORTRAIT

Franklin Carmichael.
Photograph courtesy
National Gallery
of Canada, Ottawa.

———

Franklin Carmichael,
Autumn Hillside,
1920; oil on canvas,
76 x 91.4 cm; Art Gallery
of Ontario, Toronto.
Gift of the J.S. McLean
Collection. Donated
by the Ontario Heritage
Foundation, 1988.

Like Frank Johnston, Franklin Carmichael had known the artists who would form the Group of Seven since his days at Grip Limited. Described by A.J. Casson as "a peppery little man with great determination and drive," Carmichael had trained hard to develop his skills as an artist.

At first employed as a painter in his father's carriage-making business in Orillia, Ontario, he eventually moved to Toronto to study at the Ontario College of Art and the Toronto Technical School, supporting himself with work at Grip starting in 1911. Later, he took a job at Rous and Mann. With the encouragement of Fred Varley and Arthur Lismer, Carmichael travelled to Antwerp, Belgium, in 1913 to study at the academy that Varley and Lismer had attended earlier.

When the war broke out in 1914, Carmichael returned to Toronto, where he shared a space with Tom Thomson at the Studio Building. Because of family responsibilities, he was unable to accompany the other artists on their long sketching excursions to the North. Carmichael managed instead to take short weekend sketching trips, often painting very near his home.

In contrast to Thomson's isolated trees or Johnston's stormy Algoma landscape, Carmichael paints the woods and rolling hills of Ontario farmland in *Autumn Hillside*. While the forest beyond the clump of grey rock and broken trees is dense, there is a feeling of order which suggests that we are not really in the wilderness.

Like many painters, Carmichael was acutely aware of the cycle of life, growth, death and rebirth as they are reflected in nature. In this painting, our eyes travel across the seasons and through the stages of life in the forest—from the dark and decayed foreground to the tall, green middle ground of summer and, finally, to the yellow of autumn as nature slowly gives way to the lifelessness of winter. Then the whole cycle begins anew.

Recalling the tapestry-like surface of Thomson's *The Jack Pine*, Carmichael has varied his brush strokes to suggest the very textures of nature. Thick, broad strokes describe the roughness of the rocks in the foreground, while short, blunt strokes represent the prickly needles of fir trees. To depict the yellow leaves and narrow trunks of trees in the distance, Carmichael has applied his paint more delicately.

FRANKLIN CARMICHAEL
AUTUMN HILLSIDE

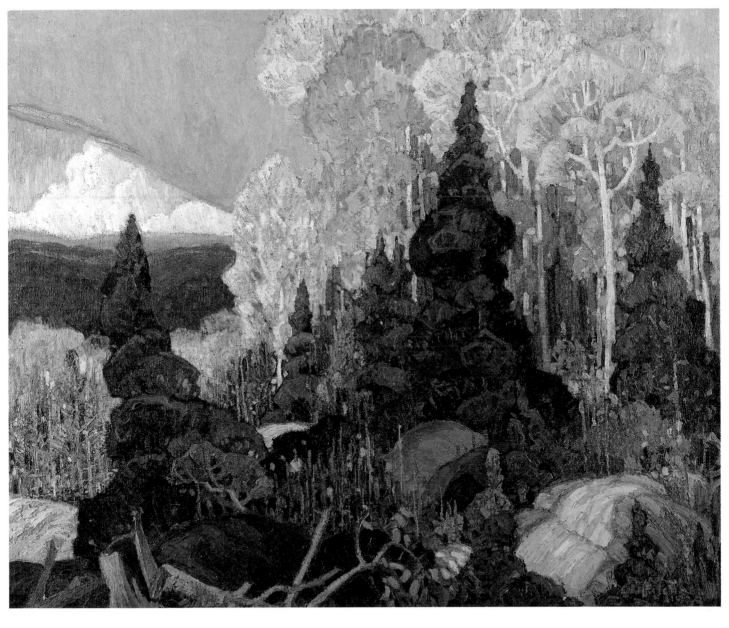

FIRST EXHIBITION CATALOGUE
SPRING 1920

A.Y. Jackson described the Group's organization as "a loose one, no officers, no bylaws and no fees." It was so loose, in fact, that Jackson himself was informed of his membership only upon his return to the city after a sketching trip. Once the Group was formed, the artists' lives continued much as before—they met for lunch now and then, took sketching trips and, a few times a year, discussed exhibition plans.

The cover of the Group of Seven's first exhibition catalogue was designed by Franklin Carmichael. Its graphic simplicity echoed the directness of the artists' statement that appeared inside. Written by Harris, it stressed that Canada, to be a real home for its people, must have its own art, free from the traditions of Europe. Despite earlier criticism in the press, most of the reviews of the exhibition were positive: Canada at last seemed ready to support its artists.

While the first exhibition displayed a variety of subjects, including street scenes and portraits, the artists generally shared the belief that the northern Canadian landscape represented the spirit of the country. In *March Storm, Georgian Bay*, Jackson aimed to capture the wild and rugged excitement of the North in a manner that was equally untamed.

At first glance, we cannot imagine a less inviting place—the cold snow clouds descend toward the horizon, blocking out the late-winter light. The trees in the distance, shaped like the jagged edge of a saw, are bent by the fierce wind, while the water has turned a chilly dark green. Jackson has applied his paint with swift, bold brush strokes, conveying the strength and energy of nature and revealing a new kind of beauty in the bitter climate.

Logo used for the Exhibition of Paintings, May 7-27, 1920, Art Museum of Toronto. Courtesy E.P. Taylor Reference Library and Archives, Art Gallery of Ontario, Toronto.

A.Y. Jackson, *March Storm, Georgian Bay (Storm Over a Frozen Lake)*, 1920; oil on canvas, 63.5 x 81.3 cm; National Gallery of Canada, Ottawa. Bequest of Dr. J.M. MacCallum, Toronto, 1944.

On a winter evening in 1920, several of the Studio Building artists, along with Frank Johnston, gathered at Lawren Harris's house to discuss their plans for a group exhibition at the Art Gallery of Toronto. They wondered what they should call themselves. While the artists shared certain ideals about a new approach to Canadian painting, there was no single theme that united their work. The only thing which could be said about all of them was that they were seven artists. Hence, the Group of Seven.

A.Y. JACKSON
MARCH STORM, GEORGIAN BAY (STORM OVER A FROZEN LAKE)

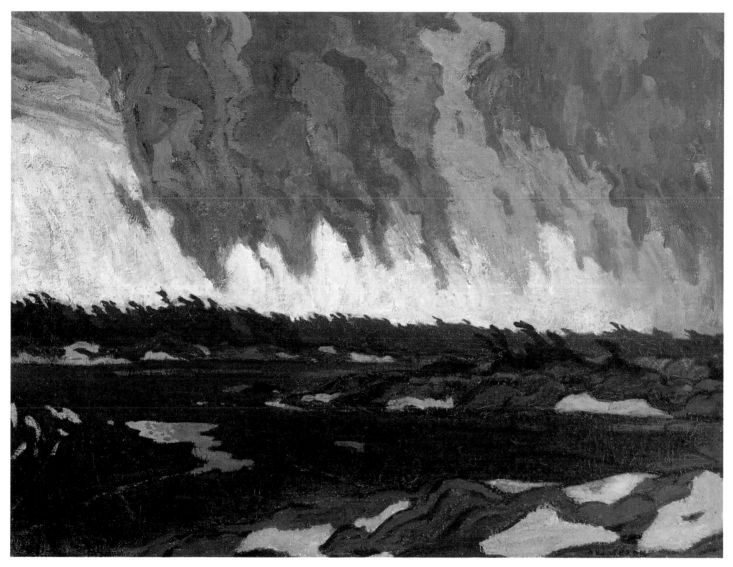

GEORGIAN BAY

F.H. VARLEY
STORMY WEATHER, GEORGIAN BAY

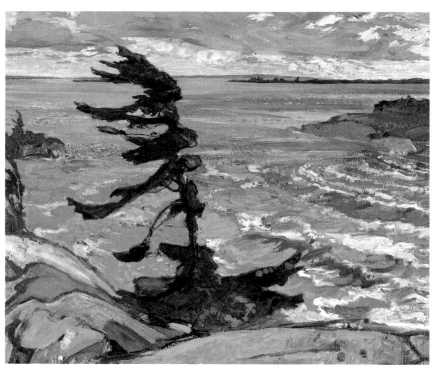

Following the Group's first exhibition, the artists continued to take sketching trips to different regions of Canada. Since 1910, Lake Huron's Georgian Bay had been a favourite destination, especially the area around Dr. James MacCallum's summer place at Go Home Bay. Famous for its sudden and dramatic changes in weather, Georgian Bay is a stark terrain dotted with tiny, rugged islands and the unexpected outcrops of trees with which the Group of Seven has become so identified.

From Arthur Lismer and Fred Varley, we have two very individual responses to this landscape. At first glance, these paintings may appear quite similar, especially in subject matter. Yet upon closer inspection, we will see differences in the ways in which the artists have applied their paint and structured their composition.

Georgian Bay was Lismer's preferred sketching ground. In *A September Gale, Georgian Bay*, he invites us to imagine ourselves in his place. By framing our view so that the top of the wind-blown tree is cut off, he suggests that we are very close to it, just as Tom Thomson did in *The Jack Pine*. Notice how everything in the painting is carefully outlined. The edge of the rocks, the grass in the foreground, each wave and each cloud in the sky have a precision about them that reminds us of Lismer's love of drawing and his previous career as a graphic designer.

In *Stormy Weather, Georgian Bay*, Varley gives us a perspective above the treetop so that we can take in the wide expanse of water and the horizon in the distance. Here, the lone tree seems frail, clinging to the rock and creating a dramatic silhouette as its windswept branches curl about its trunk like a cloak. Varley's energetic brush stroke conveys the force of the wind on the whitecaps and on the swiftly moving clouds.

While depicting essentially the same place, these paintings reinforce the idea that the artists were not simply painting what they saw, but what they felt. Our reactions to these works will be as varied and individual as were those of Lismer and Varley to Georgian Bay itself.

F.H. Varley, *Stormy Weather, Georgian Bay*, c. 1920; oil on canvas, 132.6 x 162.8 cm; National Gallery of Canada, Ottawa.

Arthur Lismer, *A September Gale, Georgian Bay*, 1921; oil on canvas, 122.4 x 163.0 cm; National Gallery of Canada, Ottawa.

ARTHUR LISMER
A SEPTEMBER GALE, GEORGIAN BAY

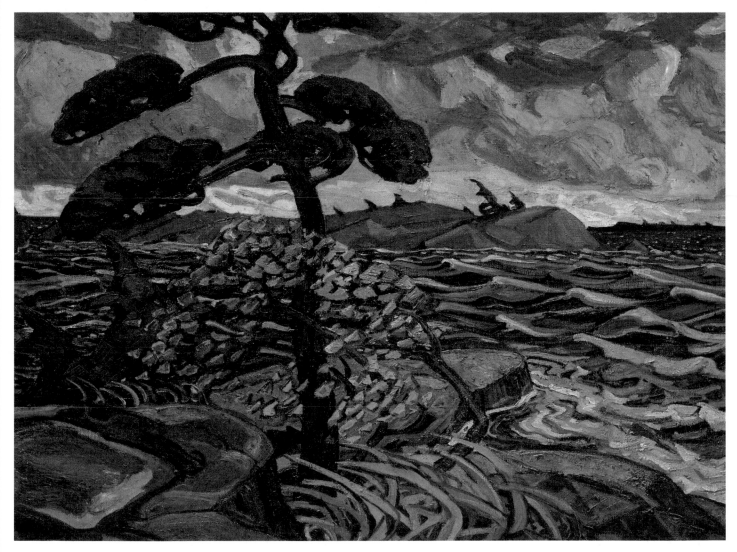

ALGOMA COUNTRY

FRANK JOHNSTON
FIRE-SWEPT, ALGOMA

When we look at many of the paintings by the Group of Seven, we see not just how these artists depicted the different landscapes of Canada but how these places made the artists feel. Between 1918 and 1921, several of the Group, including Lawren Harris, A.Y. Jackson, Arthur Lismer and Frank Johnston, travelled to Algoma, a region in northern Ontario carved by great rivers and dotted with lakes. Each found his own inspiration there. In these paintings of Algoma country, the artists move beyond the simple appearance of nature "to paint the soul of things," as J.E.H. MacDonald said, "the inner feeling rather than the outward form."

Described by Jackson as "a quiet, unadventurous man who could not swim or paddle, swing an axe or find his way in the bush," MacDonald was "awed and thrilled by the landscape of Algoma…he loved the big panorama." As Jackson later recalled, he always thought of Algoma as "MacDonald's country."

MacDonald sketched *The Solemn Land* from a railroad track overlooking the Montreal River. In this painting, he attempts to express the sombre mood of the land. Everything seems very still; even the dark clouds appear to be suspended and motionless. The mammoth hills, some wooded and some sheer rock, creep along the shores of the river like the giant claws of a prehistoric creature. To MacDonald, the

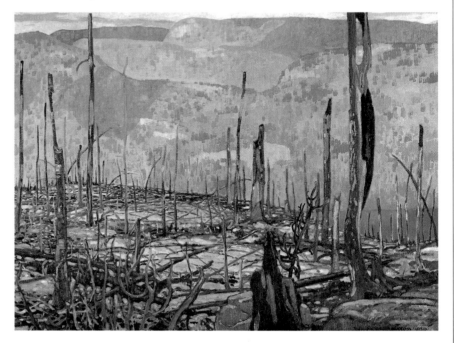

vastness of the unspoiled land filled him with "something of the feeling of the early explorers."

In *Fire-Swept, Algoma*, Johnston presents us with an unusual foreground of charred trees and broken stumps. Rather than creating a lively portrait of the Canadian wilderness, as we saw in the works of Jackson and Fred Varley, Johnston here depicts the fierce side of nature. While this image may appear bleak at first, Johnston reminds us that there is hope in the eventual regrowth of the forest. Between the blackened stumps of trees, the strength of nature emerges in the form of small green shoots, a promising sign of regeneration. In the distance, the giant green-and-mauve-coloured hills are untouched by fire, saved by the calm blue river at their base.

Frank Johnston, *Fire-Swept, Algoma*, 1920; oil on canvas, 127.5 x 167.5 cm; National Gallery of Canada, Ottawa.

J.E.H. MacDonald, *The Solemn Land*, 1921; oil on canvas, 122.5 x 153.5 cm; National Gallery of Canada, Ottawa.

J.E.H. MacDONALD
THE SOLEMN LAND

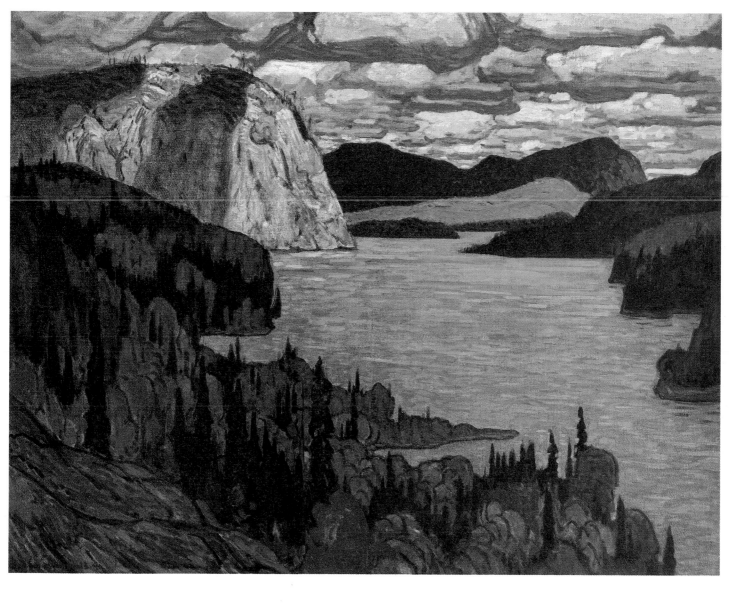

LAKE SUPERIOR

FRANKLIN CARMICHAEL
BAY OF ISLANDS

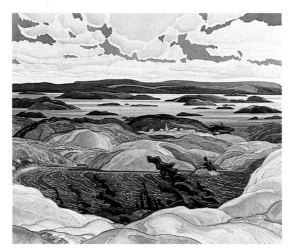

The artists' exploration of the north shore of Lake Superior had as much to do with their interest in discovering new sources of visual inspiration as it did with Lawren Harris's personal search for a landscape that would enable him to express his spiritual beliefs.

What did Harris find so attractive about this rocky land, worn smooth by ice-age glaciers and ravaged by forest fires in modern times? When compared with the earthy ruggedness of the Algoma or Georgian Bay paintings, the trunks of the leafless trees and the snow-covered hills in *First Snow, North Shore of Lake Superior* have an almost unnatural smoothness. The small trees in the foreground have been reduced to simple conical shapes, standing as sentries guarding the silence of the huge expanse of land. In the distance, we see a range of low blue hills that seems to extend beyond the frame of the painting, creating a feeling of endless, continuous space.

As Harris simplified the forms of the landscape, he also applied his paint carefully, producing a smooth, even surface and suggesting a purified, spiritual place untouched by human hands. Above the irregular and imperfect reality of earthly existence, the Lake Superior paintings allowed Harris to express the higher world of the spirit.

Franklin Carmichael's watercolour *Bay of Islands* was probably created from sketches made while he camped out on the north shore of Lake Superior with Harris and the others in 1924. The youngest member of the Group, Carmichael was determined to develop his own view of a landscape already much painted by his more established colleagues. His expert use of watercolour helped to set his work apart from theirs.

In contrast to the timelessness and stillness of the Harris painting, Carmichael's view of Lake Superior is lively and full of movement and light. The image of houses nestled in the valley of stone provides a very particular sense of time and place. Just as Harris's painting seems to be rooted in the past or in some spiritual future, Carmichael's landscape is anchored to the present. Notice how the careful and controlled use of the watercolour lends a certain delicacy to the spirit of the land, transforming it into something almost welcoming.

Franklin Carmichael, *Bay of Islands*, 1930; watercolour on paper, 44.5 x 54.6 cm; Art Gallery of Ontario. Gift from the Friends of Canadian Art Fund, 1930.

Lawren Harris, *First Snow, North Shore of Lake Superior*, 1923; oil on canvas, 123 x 153.3 cm; Vancouver Art Gallery, Founders Fund.

LAWREN HARRIS
FIRST SNOW, NORTH SHORE OF LAKE SUPERIOR

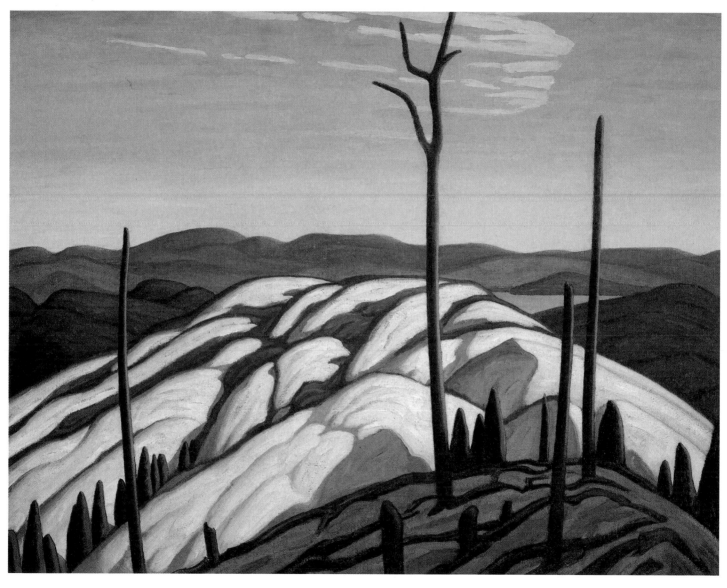

RURAL HARMONY

A.Y. JACKSON
A QUEBEC VILLAGE

The journeys to Lake Superior in the early 1920s were the last the artists made as a group. By then, they had all begun to travel to different parts of the country, exploring their own interests. Although they continued to exhibit their work as the Group of Seven, there had, in fact, been only six members for some time. Soon after the Group's first show in 1920, Frank Johnston dropped out, and in 1926, Fred Varley moved to British Columbia to accept a teaching position. That same year, A.J. Casson, who worked for Franklin Carmichael at Rous and Mann, was invited to join the Group.

Casson had great admiration for the members of the by now famous Group and was honoured to be included among their ranks. But he did not want to paint like them. "I had to develop my own style," he said later. "I began to dig out places of my own...I loved to paint villages, and I'm glad, because they're pretty much gone now. They've all changed, fallen down or been destroyed."

In Casson's *Mill Houses*, we hover like birds over an almost miniature Ontario village, which rests on the shores of the river that meanders quietly through it. In contrast to the wide-open spaces of the Group's wilderness landscapes, we do not see the sky in this painting. Instead, we are kept safe and snug amidst the closely spaced houses. The bright sunlight

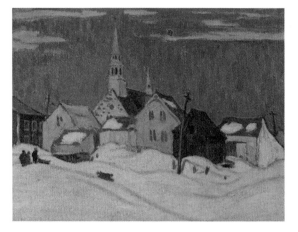

reflecting off the white stucco lends a cheerful air to the little community, where everyone is out of sight, perhaps enjoying a midday nap.

In the spring of 1921, when the deep snows of winter still lingered in the Quebec countryside, A.Y. Jackson made the first of many trips to the south shore of the St. Lawrence River. Boarding with the Plourde family on a farm near Rivière du Loup, Jackson found himself captivated by the convivial atmosphere of family life. Attracted at first to the picturesque churches that dotted the landscape, he soon became fascinated by the effects of the sun and wind on the ever-shifting colour and texture of the snow.

In *A Quebec Village*, the lofty church steeple towers over the buildings clustered beside it, dividing the intense blue of the sky from the softly curving drifts of snow. Jackson's sense of comfort and contentment at painting his native Quebec are evident in this work—we can almost hear the laughter of children tobogganing and feel the warm winter sun on our backs.

A.Y. Jackson, *A Quebec Village*, 1921; oil on canvas, 53.7 x 66.3 cm; National Gallery of Canada, Ottawa.

A.J. Casson, *Mill Houses*, 1928; oil on canvas, 76.2 x 91.4 cm; Collection of the Agnes Etherington Art Centre, Queen's University. Gift of Mr. and Mrs. Duncan McTavish, 1955. Photograph by Larry Ostrom.

A.J. CASSON
MILL HOUSES

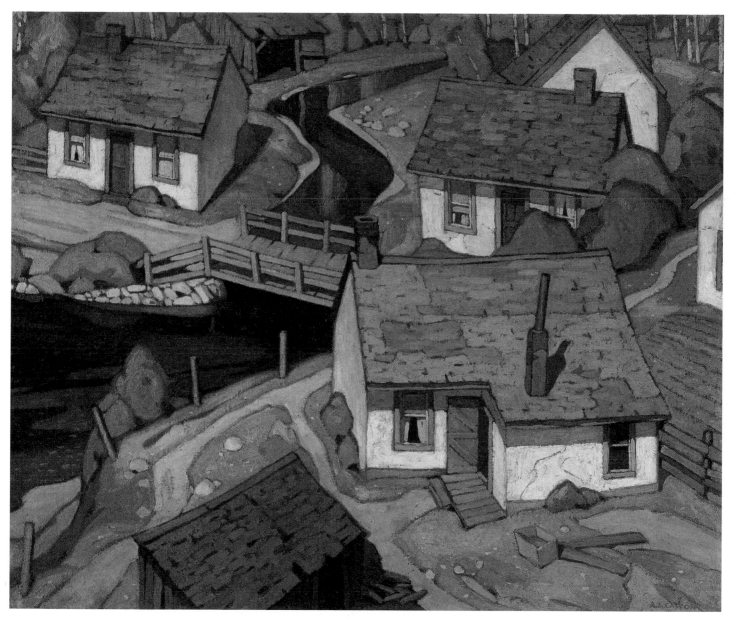

THE EFFECTS OF INDUSTRY

FRANKLIN CARMICHAEL
THE NICKEL BELT

In the early years of the 20th century, the rapid growth of the lumber business and the opening of nickel, copper and silver mines were all promising signs of the country's much-needed industrial expansion. While most of the Group of Seven artists were interested in an uninhabited wilderness, some of them occasionally painted their reaction to the potentially negative effects of industry on the land.

In 1921, Lawren Harris visited the Maritimes, where he was shocked by what he saw in the mining towns. A long history of unemployment, union battles and strikes had created a legacy of poverty that would survive for decades to come. Far from the pristine light of Harris's Lake Superior, we peer into a dim navy and turquoise sky, where tombstone-like houses, empty streets and a barren land are bathed in an eerie orange glow.

For Harris, in pursuit of a landscape that would foster enlightenment and spiritual growth, the images of the poor Maritime areas symbolized the darkness of the human spirit. He greatly sympathized with the plight of these people, fearing that their physical poverty might lead to a poverty of the mind.

Travelling past the Sudbury-area nickel mines on the way to his summer home in the La Cloche region of northern Ontario, Franklin Carmichael also had a chance to see the impact of industry on the landscape. In *The Nickel Belt*, Carmichael depicts the smoke from the nickel smelter making its way skyward, away from the rolling hills and eroded rock.

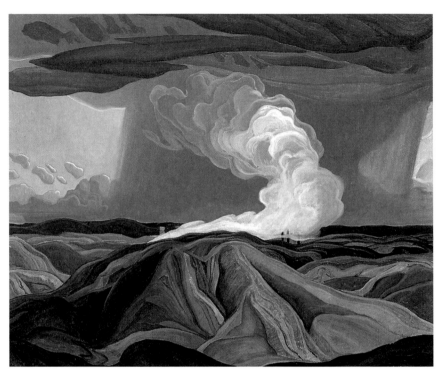

Like any painting, *The Nickel Belt* will be understood differently by the eyes of different times. Even in Carmichael's day, audiences would have experienced mixed reactions to this portrait of natural resources developed amid the splendour of the North. Some would have seen the rising smoke as a sign of progress, while others knew enough to blame the smelter for the dead fish floating in their lakes.

Franklin Carmichael, *The Nickel Belt*, 1928; oil on canvas, 101.8 x 122 cm; Firestone Art Collection, The Ottawa Art Gallery. Gift of the Ontario Heritage Foundation to the City of Ottawa.

Lawren Harris, *Miners' Houses, Glace Bay*, c. 1925; oil on canvas, 107.3 x 127 cm; Art Gallery of Ontario, Toronto. Bequest of Charles S. Band, 1970.

LAWREN HARRIS
MINERS' HOUSES, GLACE BAY

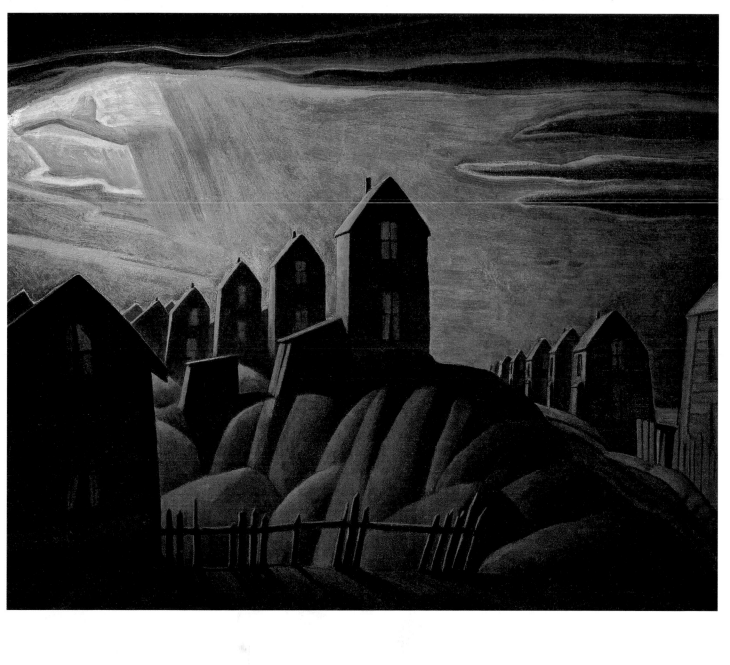

THE ROCKY MOUNTAINS

F.H. VARLEY
THE CLOUD, RED MOUNTAIN

The drama and the splendour of the Canadian Rockies were a strong attraction for the members of the Group. A.Y. Jackson travelled there in 1914, and later, in the 1920s, Lawren Harris, Fred Varley, J.E.H. MacDonald and Arthur Lismer individually discovered the magnificence of the mountains.

In 1926, Varley accepted a teaching position in Vancouver, where he would live for the next 10 years. For the first time, he became really enchanted with the Canadian landscape. Overwhelmed and enthused by the vast beauty of the sky, sea and mountains that surrounded him, he wrote to a friend: "British Columbia is heaven." For the free-spirited and passionate Varley, it was a time to experiment with the expressive possibilities of colour and radical composition.

The Cloud, Red Mountain is one of four paintings Varley created on his first excursion into the Coast Mountains, north of Vancouver. Instead of focusing on a mound of rock, he invites us to lose ourselves in the shape of the sky as it is bound by the painted profiles of the mountaintops and the undulating curves of the clouds. These could be the happy colours of our dreams: golden clouds, contrasting with a greenish blue sky that becomes yellow at the horizon of rich red rocks.

While the mountains were an unexpected discovery for Varley, they were, for Harris, the next stage in his continuing search for a landscape that would better enable him to express through art his spiritual ideals. In the lofty summits of the Rocky Mountains, Harris found a symbol for the highest point to which humanity can aspire—the achievement of spiritual truth and knowledge.

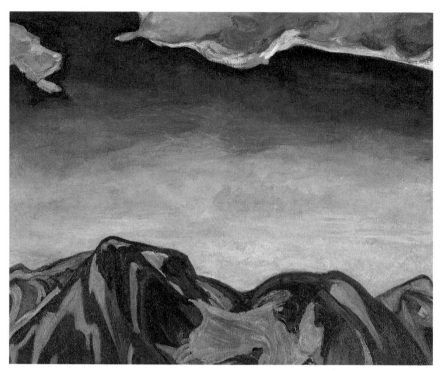

In his painting *Mt. Lefroy*, Harris has greatly simplified the jagged rocks into a smoothly carved surface where giant fingers of snow cling evenly to its side. The lower mountains act as stepping stones to the top, encouraging a spiritual journey upwards, for the artist as well as the viewer.

Harris believed that certain colours carried meaning: white symbolized truth; blue, faith; and yellow, divine knowledge. To emphasize the mountain peak as a divine place, Harris painted a cloud that floats like a halo behind it. Beyond the starkness of the Lake Superior works, those of the Rockies express Harris's personal quest for spiritual truth—a life's voyage we can follow in his paintings.

F.H. Varley, *The Cloud, Red Mountain*, c. 1928; oil on canvas, 86.8 x 102.2 cm; Art Gallery of Ontario, Toronto. Bequest of Charles S. Band, 1970.

Lawren Harris, *Mt. Lefroy*, 1930; oil on canvas, 133.5 x 153.5 cm; McMichael Canadian Art Collection.

LAWREN HARRIS
MT. LEFROY

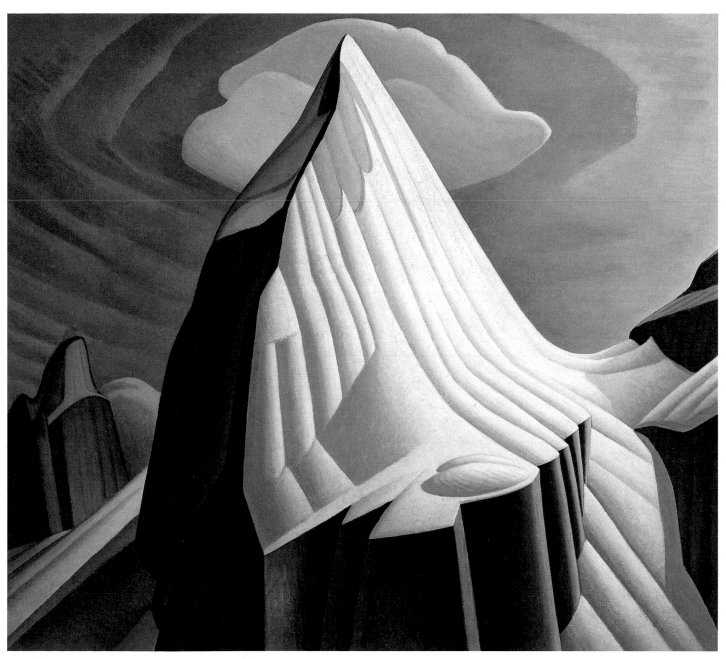

PORTRAITS

LAWREN HARRIS
DR. SALEM BLAND

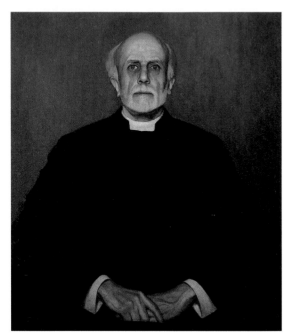

Although Arthur Lismer created many portrait sketches of his friends, Lawren Harris and Fred Varley were the only two members of the Group to produce portraits in oil. Varley actively sought commissions; for him, portraiture was a way to make a living. Harris, on the other hand, invited his subjects to sit for him and painted only people he found interesting. In all, he produced just 11 portraits.

The stiff white collar and black tunic of Harris's subject in *Dr. Salem Bland* clearly identify him as a church minister. Sitting upright, his body rigid with thought, Bland stares beyond us with cool blue eyes and a firmly set mouth. The seriousness and determination of the man are echoed in his pose, which forms a triangle—a strong, stable shape that reinforces the depiction of this dynamic personality. Bland was an independent Methodist minister whose outspokenness had been known to cost him his job.

If Bland represented a kind of spiritual leader for Harris, then the subject in *Vera* served as spiritual inspiration to Varley. We are immediately struck by the differences between these two portraits. One is executed with smooth edges and naturalistic detail, while the other is painted freely with richly textured paint and colours not readily found in nature.

Varley's use of colour was inspired by his feelings for Vera, whom he considered an important influence. For Varley, certain colours had particularly expressive properties—green and blue were associated with the spiritual, violet with beauty. If the reds and browns he had used in the painting of a Gypsy woman rooted her in the earth, then the cool blues and greens he used to paint Vera transported her to the higher sphere of the spirit.

Unlike Harris, who favoured a rather formal presentation of his sitters, Varley preferred more relaxed poses. Here, Vera stares at us in a dreamy way, with a gentle smile on her lips. Her clothes are draped softly, and the curving lines of her collar carry our eyes upward to the sweep of her hair and then to a richly painted background.

Just as the landscape paintings reflect the individual hands behind the brush, so do the portraits reveal each artist's distinct personality: Harris, the neatly dressed organizer of the Group, with the tidy, ordered studio; and Varley, the bohemian, casual in his appearance, spontaneous and emotional in his expression.

Lawren Harris, *Dr. Salem Bland*, 1925; oil on canvas, 103.5 x 91.4 cm; Art Gallery of Ontario, Toronto. Gift of the *Toronto Daily Star*, 1929.

F.H. Varley, *Vera*, 1931; oil on canvas, 61 x 50.6 cm; National Gallery of Canada, Ottawa. Vincent Massey Bequest, 1968.

F.H. VARLEY
VERA

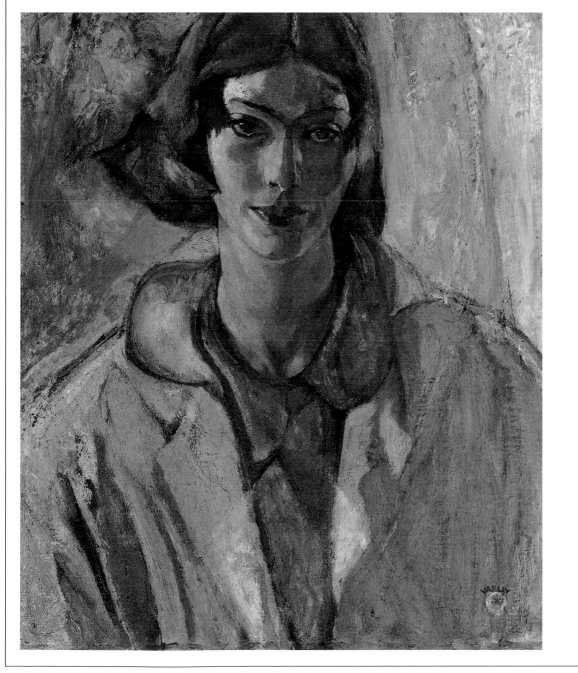

TO THE ARCTIC AND BEYOND

A.Y. JACKSON
THE "BEOTHIC" AT BACHE POST, ELLESMERE ISLAND

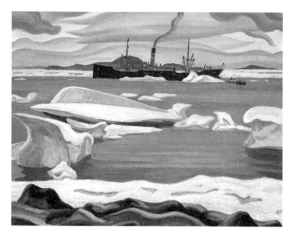

"Art must take to the road and risk all for the glory of adventure," wrote Lawren Harris in 1922 in the third Group of Seven exhibition catalogue. Among the most exciting frontiers for the artists was the Arctic. Both Harris and Fred Varley travelled and painted there, but A.Y. Jackson was the first to visit Canada's most remote region.

In 1927, Jackson was invited to travel aboard the *Beothic*, a chartered ship that delivered supplies, police officers and scientists to northern RCMP posts. Sketching aboard the cramped, rocking ship, zigzagging through ice fields, proved difficult, and working on land required great speed. In his diaries, Jackson reported: "I made a sketch of the *Beothic* anchored out a quarter of a mile from shore unloading supplies....We had little time to spare...the Captain was afraid of ice closing in on us, and it nearly did too."

Throughout the 1920s, the members of the Group continued to go their separate ways, discovering other parts of Canada and taking jobs according to their need to support themselves and their families. Varley, J.E.H. MacDonald and Arthur Lismer held teaching positions, while Franklin Carmichael and A.J. Casson worked as commercial artists. Although Jackson also taught briefly, he and Harris devoted most of their time to travelling the country and painting.

Even though the artists' interests became more diverse, they continued to exhibit as a group, holding eight Group of Seven exhibitions between 1920 and 1931. During this time, their popularity grew immensely. Enthusiastic reception of their work in Britain further increased their reputation at home.

If they had begun as rebels, the members of the Group had, by the end of the decade, begun to symbolize the art establishment. Fittingly, they were challenged by artists who resented their domination of the Canadian art scene. In 1931, the Group, which in its last exhibition welcomed the contributions of 28 other artists, decided to disband and form a new group that better represented artists from across the country. The Canadian Group of Painters held its first show in 1933, exhibiting the work of 52 artists, including the Group of Seven.

In Varley's *Open Window*, we stare once again out into the vast Canadian landscape. From the shelter of the house, we look through the window and across the smooth beach into a new dawn for Canadian art, a dawn awakened by the Group of Seven—freeing artists to see and paint Canada in their own way and opening our eyes to the beauty and mystery of our land.

F.H. VARLEY
OPEN WINDOW

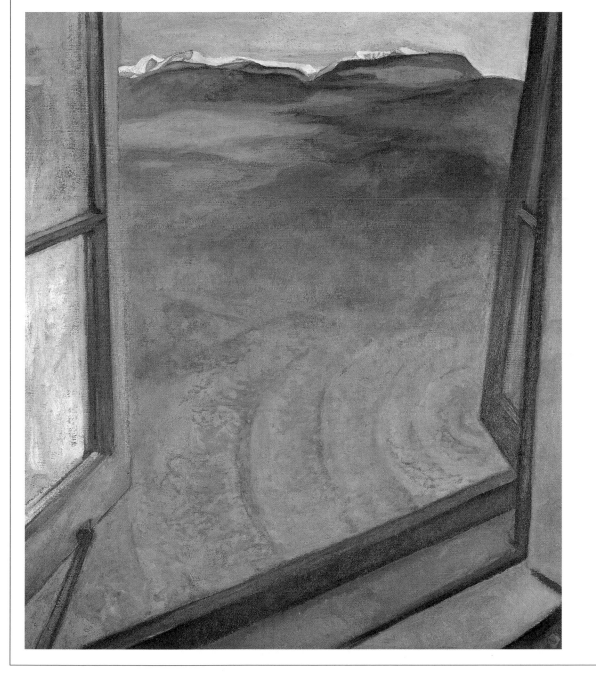

AFTER THE GROUP DISBANDS

FRANKLIN CARMICHAEL (b. Orillia, Ontario, 1890; d. Toronto, Ontario, 1945). Throughout the Group of Seven years, Carmichael continued to work as a commercial artist, developing his skills as a watercolourist and printmaker. In 1932, he left commercial art to accept a teaching position at the Ontario College of Art.

ALFRED JOSEPH CASSON (b. Toronto, Ontario, 1898; d. Toronto, 1992). In 1925, Casson joined with Franklin Carmichael and F.H. Brigden, another commercial artist and painter, in founding the Canadian Society of Painters in Water Colour. During his membership in the Group of Seven from 1926 and in the Canadian Group of Painters in 1933, he worked as a commercial artist. Following his retirement in 1958, he continued to paint in his clear, linear style.

LAWREN STEWART HARRIS (b. Brantford, Ontario, 1885; d. Vancouver, British Columbia, 1970). In his search for a "deeper and more universal expression," Harris had, by the early 1930s, abandoned landscape painting for abstract art as a more suitable form of expression for his spiritual beliefs. In 1934, he left Canada for the United States and, in 1940, returned to settle in Vancouver, inspiring future generations of abstract artists.

ALEXANDER YOUNG JACKSON (b. Montreal, Quebec, 1882; d. Kleinburg, Ontario, 1974). For the rest of his long and prolific life, Jackson continued his exploration of various parts of Canada, upholding the ideals of the Group of Seven years after its members had gone their separate ways. He taught occasionally and encouraged the careers of many young artists, especially those of the Beaver Hall Hill Group in Montreal.

FRANCIS (FRANK) HANS JOHNSTON (b. Toronto, Ontario, 1888; d. Toronto, 1949). Johnston, who later changed his first name to Franz, participated only in the first Group of Seven exhibition, in 1920. From 1921 to 1924, the year he officially resigned from the Group, he was principal of the Winnipeg School of Art. Upon his return to Toronto, he taught briefly at the Ontario College of Art and continued his career as a successful artist, preferring to be independent of any groups.

ARTHUR LISMER (b. Sheffield, England, 1885; d. Montreal, Quebec, 1969). While Lismer continued to paint, his primary career increasingly became that of an educator, enthusiastically promoting the ideals of the Group of Seven. From 1927 to 1938, he designed art-education courses for children at the Art Gallery of Toronto and later, from 1941 to 1967, at the Montreal Museum of Fine Arts. All the while, he maintained a busy schedule touring and lecturing on the importance of art education.

JAMES EDWARD HERVEY MACDONALD (b. Durham, England, 1873; d. Toronto, Ontario, 1932). Despite his frail health throughout the 1920s, MacDonald kept up a vigorous pace of travelling to more distant parts of Canada, from the Maritimes to the Rockies, which he visited every summer from 1924 to 1930. At the same time, he was art editor for the *Canadian Forum* and a director, until his death, at the Ontario College of Art. His death was a great loss to the Group and was a strong contributing factor to its disbanding.

FREDERICK HORSMAN VARLEY (b. Sheffield, England, 1881; d. Toronto, Ontario, 1969). Known as the "gypsy" of the Group for his bohemian life style and constant wanderings, Varley was rarely settled in any one place. Following his Vancouver sojourn from 1926 to 1936, he returned to central Canada, drifting between cities trying to make a living as a portraitist and a teacher. Occasionally, he sketched in more distant parts of the world, such as the Arctic and Russia, with Toronto becoming his base for the last 25 years of his life.

THOMAS JOHN THOMSON (b. Claremont, Ontario, 1877; d. Canoe Lake, Ontario, 1917). Thomson was never an official member of the Group of Seven, because he died three years before its formation, but he remained an important inspiration to the artists. Thomson's love and enthusiasm for the Canadian northland, as well as his bold and exciting use of colour, lived on in their work and in their spirit.

SKETCHING GROUNDS

1. Ellesmere Island,
Northwest Territories

2. Coast Mountains,
British Columbia

3. Rocky Mountains,
British Columbia/Alberta

4. North Shore of Lake
Superior, Ontario

5. Algoma Region,
Ontario

6. La Cloche Region,
Ontario

7. Algonquin Park,
Ontario

8. Toronto, Ontario

9. South Shore of
St. Lawrence River,
Quebec

10. Glace Bay,
Cape Breton Island,
Nova Scotia

SELECTED SOURCES

There is a wealth of written material on the Group of Seven, both art historical and critical. I am especially indebted to the writings of the artists themselves for their personal insights into their works and experience. The list below offers a few sources of general information on the Group and includes the publications from which the quotes in this book were taken. —A.N.

Adamson, Jeremy. *Lauren S. Harris: Urban Scenes and Wilderness Landscapes, 1906-1930* (exhibition catalogue). Toronto: Art Gallery of Ontario, 1978.

Bice, Megan. *Light and Shadow: The Work of Franklin Carmichael* (exhibition catalogue). Kleinburg: McMichael Canadian Art Collection, 1990.

Bridges, Marjorie Lismer. *A Border of Beauty*. Toronto: Red Rock, 1977.

Casson, A.J. "Group Portrait," *Saturday Night*, March 1986.

Duval, Paul. *The Tangled Garden*. Scarborough: Cerebrus Publishing Company Limited and Prentice-Hall of Canada Ltd., 1978.

Groves, Naomi Jackson. *A.Y.'s Canada*. Toronto and Vancouver: Clarke, Irwin, and Company Limited, 1968.

Hunkin, Harry. *A Story of the Group of Seven*. Toronto: McGraw-Hill Ryerson Ltd., 1976.

Jackson, A.Y. *A Painter's Country*. Toronto and Vancouver: Clarke, Irwin, and Company Limited, 1976.

McLeish, John A.B. *September Gale*. Toronto: J.M. Dent and Sons (Canada) Ltd., 1973.

Mellen, Peter. *The Group of Seven*. Toronto: McClelland and Stewart, 1970.

Murray, Joan. *The Best of the Group of Seven*. Toronto: McClelland and Stewart, 1993 (in paperback).

—————. *Northern Lights: Masterpieces of Tom Thomson and the Group of Seven*. Toronto: Key Porter Books Limited, 1994.

—————. *Tom Thomson: The Last Spring*. Toronto, Oxford: Dundern Press Ltd., 1994.

Reid, Dennis. *The Group of Seven* (exhibition catalogue). Ottawa: National Gallery of Canada, 1970.

—————. *The MacCallum Bequest* (exhibition catalogue). Ottawa: National Gallery of Canada, 1969.

Robertson, Nancy. *J.E.H. MacDonald, R.C.A., 1873-1932* (exhibition catalogue). Toronto: Art Gallery of Toronto, 1965.

Thom, Ian. *A.J. Casson: Early Works* (exhibition catalogue). Kleinburg: McMichael Canadian Art Collection, 1984.

Toronto, Art Gallery of Toronto. *A.Y. Jackson Paintings, 1902-1953* (exhibition catalogue). Toronto: Art Gallery of Toronto, 1953.

—————. *Arthur Lismer Paintings, 1913-1949* (exhibition catalogue). Toronto: Art Gallery of Toronto, 1950.

—————. *F.H. Varley Paintings, 1915-1954* (exhibition catalogue). Toronto: Art Gallery of Toronto, 1954.

Varley, Christopher. *F.H. Varley* (exhibition catalogue). Edmonton: Edmonton Art Gallery, 1981.

INDEX